CHRISTOPHER PRATT: A RETROSPECTIVE

Self-Portrait, 1968
graphite on paper

ITINERARY

VANCOUVER ART GALLERY
Vancouver, British Columbia
November 23, 1985 to January 26, 1986

THE ART GALLERY OF ONTARIO
Toronto, Ontario
February 21 to April 20, 1986

MEMORIAL UNIVERSITY GALLERY
St. John's, Newfoundland
May 8 to June 22, 1986

DALHOUSIE ART GALLERY
Halifax, Nova Scotia
July 10 to August 31, 1986

CONTENTS

Pratt, Christopher, 1935-
Christopher Pratt, a retrospective
Catalogue text by Joyce Zemans.
Bibliography: p. 89
ISBN 0-920095-53-4
I. Pratt, Christopher, 1935- – Exhibitions
I. Zemans, Joyce, 1940-
II. Vancouver Art Gallery. III. Title.
N6549.P72A4 1985 760'.092'4 C85-091592-9

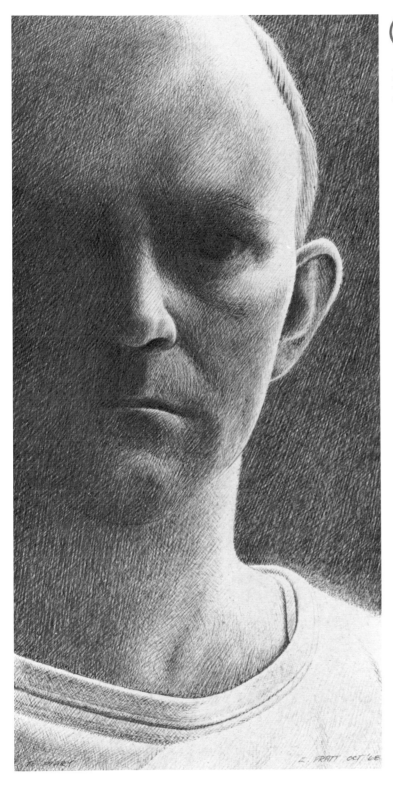

CHRISTOPHER PRATT

A RETROSPECTIVE ORGANIZED BY THE VANCOUVER ART GALLERY.
MADE POSSIBLE BY GENEROUS SUPPORT FROM CONTINENTAL BANK
OF CANADA. ASSISTED BY A GRANT FROM THE CANADA COUNCIL.

CATALOGUE BY JOYCE ZEMANS

Apartment, 1976
oil on masonite

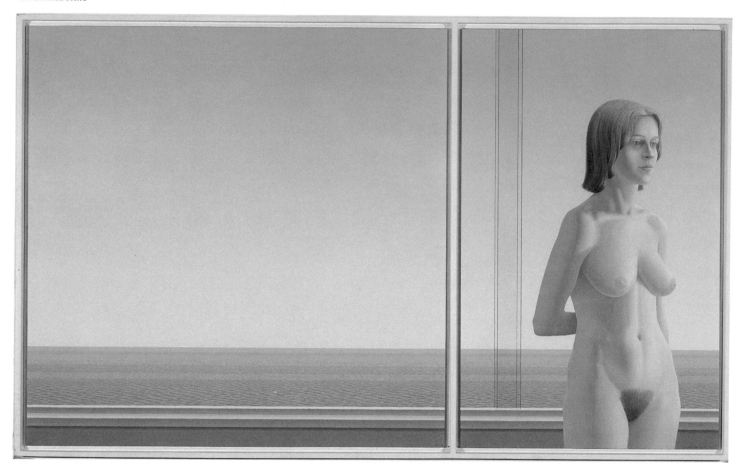

As *Christopher Pratt: A Retrospective* winds its way eastward from Vancouver through Toronto, Halifax and St. John's, a large number of Canadians will be given the opportunity to view the collected works of this senior Canadian painter for the first time.

Continental Bank of Canada is proud to play a part in bringing this outstanding retrospective to Canadians across the country and to honour Christopher Pratt and his major contribution to Canadian art. Our sponsorship of this event marks an ongoing commitment to the cultural life of the communities in which we do business and to a continued celebration of Canadian excellence.

On behalf of Continental Bank, I would like to salute the Vancouver Art Gallery and guest curator Professor Joyce Zemans for their extraordinary efforts in making this much awaited event a reality.

David A. Lewis
President and Chief Executive Officer
Continental Bank of Canada

It is appropriate that the Vancouver Art Gallery, with its strong commitment to the art of its own region, host the travelling retrospective of Christopher Pratt. Pratt, an Officer of the Order of Canada, is foremost a Newfoundlander. Thirteen years old when Newfoundland joined Canada in 1949, Pratt has committed himself to a lifetime of exploring the themes, the "inherited myths" of the Newfoundland experience.

Although Pratt has continuously drawn on the Newfoundland landscape as subject matter, guest curator Joyce Zemans proposes in the following pages that architectural imagery has proven to be his most complex and enduring theme:

"For Pratt the simple clapboard houses of Newfoundland came to denote both physical shelter and psychological refuge."

Christopher Pratt is, as well as a visual artist, a poet:

"As a sailor I have a feeling for the boat in the water, a verb. As a painter I have a feeling for the boat as an object, a noun."

We are very pleased to be able to organize a retrospective exhibition of work by Christopher Pratt, painter, sailor and poet. Such a retrospective has proved difficult to organize in the past. We are therefore indebted to guest curator Joyce Zemans, to the artist and to the lenders who agreed to share their works with us. They include: Alcan Smelters and Chemicals Ltd., Art Gallery of Hamilton, Art Gallery of Ontario, Art Gallery of York University, Mrs. Doreen Ayre, Wilfrid Ayre, Beaverbrook Art Gallery, Mrs. Lieda Bell, C.I.L. Collection, Bell and Gerry Campbell, Joan Carlisle-Irving, Confederation Centre Art Gallery and Museum, Dalhousie University Art Gallery, Department of External Affairs, Government of Canada, Anna Elton-Morris, James Fleck, George Gardiner, Edythe Goodridge, John and Margo Green, Richard and Sandra Gwyn, Richard Ivey, Mr. and Mrs. Rawdon Jackson, Dr. H.H. Just, Lavalin Inc., Mr. and Mrs. J. Lazare, London Regional Art Gallery, J. Ron Longstaffe, Lois and Kenneth Lund, Memorial University Art Gallery, Mira Godard Gallery, Mr. and Mrs. John H. Moore, National Gallery of Canada, Norcen Energy Resources Limited, Owens Art Gallery, Mr. and Mrs. R. Pafford, Polysar Ltd., Mrs. Christine Pratt, Christopher Pratt, Mary Pratt,

Philip Pratt, Sonia Dawe Ryan, David P. Silcox and Linda Intaschi, Mr. and Mrs. William Teron, Mr. and Mrs. Irving Underman, University of Lethbridge Art Collection and many others who wish to remain anonymous. Professor Zemans not only selected the works for the exhibition but also produced the insightful text for the catalogue.

An exhibition of this scale represents an enormous amount of work and coordination for the staff of the Vancouver Art Gallery. I would like to express my appreciation to them, especially: Scott Watson, Curator, who has organized the exhibition and tour; Helle Viirlaid, Registrar, Ellen Thomas and Candy Caple of the Registration Department; Hazel Currie, Publications Coordinator; Jim Jardine and Stan Douglas, Photographers; Rosemary Emery, Exhibition Coordinator and Diane Parker, Curatorial Secretary; and the Preparation Department, Jim Parker, Chief Preparator; Keith Mitchell, Assistant Chief Preparator; Glen Flanderka, Paula O'Keefe, Michael Trevillion and Bruce Wiedrick, Preparators.

For their efforts in facilitating the shipping of the works, I would like to thank David Elliott, George Ettinger, Emile Mongrain and Odette Simoneau of the National Museums Corporation of Canada and Philip Ottenbrite of Mira Godard Gallery, Toronto.

We are especially grateful to Continental Bank of Canada, its President and Chief Executive Officer, David A. Lewis and its Senior Vice-President, Corporate Development, Jeffrey Smyth.

In a period of diminishing resources, carefully researched exhibitions are becoming increasingly difficult to finance. Through their sponsorship of the exhibition and catalogue, Continental Bank of Canada has directly contributed towards art historical scholarship and a permanent record of this important exhibition.

Jo-Anne Birnie Danzker
Director, Vancouver Art Gallery

The curator of any exhibition must rely heavily on the assistance and support of gallery staff, colleagues and lenders. Most of all, I am indebted to Christopher and Mary Pratt. Their generosity with their time and information, their openness and their willingness to share, and their warm hospitality, made my work on this exhibition and catalogue not only interesting but enjoyable.

I want particularly to thank the collectors who welcomed me into their homes and allowed me to examine their art. Only through their generosity and their willingness to lend cherished work of art could such an exhibition be mounted.

I am indebted to Luke Rombout, who, as former director of the Vancouver Art Gallery, initiated this project and invited me to organize this exhibition. After his departure from the Gallery, Jo-Anne Birnie Danzker assumed a leadership role in this project. Curator Scott Watson's encouragement and assistance have made my task additionally interesting and rewarding. The Vancouver Art Gallery staff, and in particular, Rosemary Emery and Hazel Currie, have worked diligently towards the success of this exhibition and catalogue.

I deeply appreciate the assistance of David Silcox who shared his knowledge of Pratt and his art unstintingly. In Toronto, at the Mira Godard Gallery, Mira and her staff, and especially Philip Ottenbrite, have been both helpful and supportive. At the library of the Art Gallery of Ontario, Randall Speller and Larry Pfaff were, as always, ready to help. The research efforts of Victoria Evans and Francine Hill made my task easier and offered important insights. Cecile Pearl patiently read and criticized my work. Charis Wahl edited it incisively. Marie Gonsalves was supportive and helpful in typing this manuscript.

The Continental Bank of Canada has proven itself, once again, to be a generous supporter of the arts. Without its assistance this catalogue would not have been possible.

Finally, I want to thank my family. My husband, Fred, and my children, Deborah, David and Marcia, provided the support and understanding that made it possible for me to find the time to write.

Joyce Pearl Zemans
Guest Curator
Dean, Faculty of Fine Arts,
York University

The imagining powers of our mind develop around two very different axes. Some get their impetus from novelty; they take pleasure in the picturesque, the varied and the unexpected. The imagination that they spark always describes a springtime. In nature, these powers, far from us but already alive, bring forth flowers.

Others plumb the depths of being. They seek to find there both the primitive and the eternal. They prevail over season and history. In nature, within us and without, they produce seeds — seeds whose form is embedded in a substance, whose form is eternal.

Gaston Bachelard[1]

Christopher Pratt is an artist in mid-career. Yet his imagery has taken hold and implanted itself within the minds of Canadians. His has been a search for eternal forms that he has seldom compromised. As a student at Mount Allison in the 1950s, Pratt recognized the power of abstract art but he also believed that to communicate as an artist he had to work with familiar images. He began to reconstruct the visible world in light of his own experience while acknowledging modernist concerns to integrate structure into meaning.

To do so he had to create his own visual language. Neither narrative signs nor metaphors for reality, his paintings emerge into consciousness as the direct result of the artist's imagination rather than through any attempt to reproduce, interpret or symbolize reality. As he describes it, "The birth process of the work of art begins with zero. The act of creation is the production of one. And the distance between zero and one is even greater than the distance between one and infinity."[2]

Though a Newfoundlander and a Canadian, the source of Pratt's conceptual and ordered vision can be clearly linked to the Precisionist tradition in American art. Art historians such as John Baur and Barbara Novak have traced the evolution of this predominantly east-coast style from the early limners and John Singleton Copley through the nineteenth-century "Luminists" to twentieth-century artists such as Charles Sheeler, Charles Demuth, Edward Hopper and contemporary abstract geometric artists like Sol Lewitt.[3] Novak attributes this tradition's strong tendency towards abstract formal design and its great feeling for the "thingness of things" to an indigenous respect for measurement, factuality and scientific values.[4] Pratt was instinctively attracted to similar values and it is not coincidence that he studied engineering before deciding to become a painter. In its anonymous surfaces, its sharp clarification of objective forms, its emphasis on light and space, its classical silence and its planar stress, his art embodies the definitive aspects of this style.

Pratt was heir to the inherited myths of the Newfoundland experience, particularly those originated by the province's poet laureate and Pratt's Great-Uncle, E.J. Pratt. But if E.J. Pratt's vision, in which man was locked in mortal combat with a hostile nature, conditioned Pratt's early artistic experience, it holds little interest for the mature artist. Though knowledgeable in the natural sciences and in biology, a fisherman and a lover of animals, Pratt envisions the universe as a "geophysical entity in which the biological is rare."[5]

Many historians and critics have linked Pratt's art to a Canadian "Atlantic regional school of magic realism," positing Alex Colville as its Mount Allison mentor.[6] However, Michael Greenwood is accurate when he suggests that "to associate Christopher Pratt with any kind of realist purpose is . . . to completely misinterpret the nature of an art concerned, by the painter's own admission, with defining qualities of experience rather than with the portrayal of specific objects or events."[7] Though artists like Hugh Mackenzie, Tom Forrestall and D.P. Brown were, along with Christopher and Mary Pratt, students at Mount Allison when Colville taught there, one cannot generalize about the similarities in their work.

Though not a realist, Pratt was, without doubt, bolstered by Colville's example in his determination to remain tied to recognizable images. Like Colville he has made a particular geographic place the source of his art; and like him, Pratt relies on measure and precision, working through a long and extensive process of refinement. Their differences, however, are too great for them to share an aesthetic context. Colville's art speaks of particular place and time; Pratt's imagery often conflates the two into an abstracted ideographic image. Colville has pointed out that their essential difference lies in the relationship of the artist to the work:

"I once said to Christopher Pratt that the real difference between our stuff is that . . . the person in his paintings or prints is the person who is looking at them, the consciousness is outside the work. For me this is absolutely out. There has to be an [internal] consciousness, who could be animal or human."[8]

While Colville insists that he, and only he, is experiencing the scene portrayed and that the viewer must identify with him, Pratt removes his presence from the painting. The spectator must confront and experience the image directly.

Pratt is more rightly the spiritual heir to the Precisionist tradition — a tradition known to both Colville and Lawren P. Harris. He, however, has developed from it a language that speaks as deeply as pure abstraction. Founded in his experience of the Avalon Peninsula, Pratt's art is about eternal truths. It is about belonging and about alienation, it is about life and death. He has plumbed the depths of being to create images that prevail over season and history. They capture our imagination and implant within us seeds — "seeds whose form is embedded in a substance, whose form is eternal."

NOTES: PAGE 80

Self-Portrait, 1961
oil on canvas

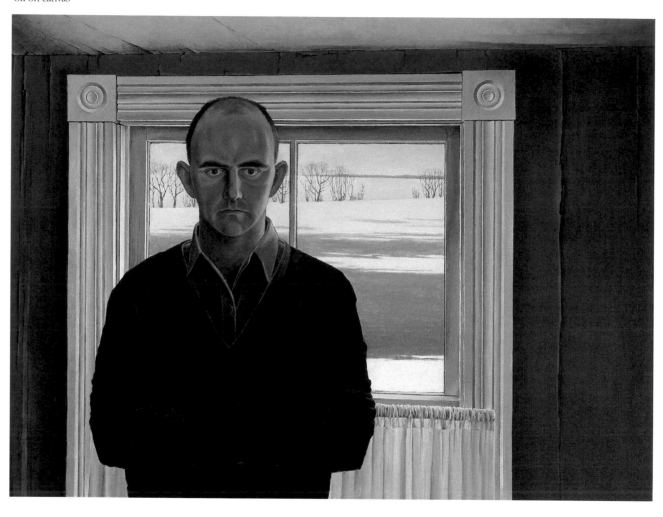

"An environment turned outward to the sea, like so much of Newfoundland, and one turned towards inland seas, like so much of the Maritimes, are an imaginative contrast; anyone who has been conditioned by one in his earliest years can hardly become conditioned by the other in the same way . . . And what can there be in common between an imagination nurtured on the prairies, where it is a centre of consciousness diffusing itself over a vast flat expanse stretching to the remote horizon, and one nurtured in British Columbia, where it is in the midst of gigantic trees and mountains leaping into the sky all around it, and obliterating the hori zon everywhere?"

Northrop Frye[1]

Christopher Pratt's imagination was formed by the flat barren landscape of Newfoundland's Avalon Peninsula and by the sea that encircles and permeates it. His first paintings were of the sea, and the sea would remain a constant theme within his work. But a person's world view, his *Weltanschauung*, is determined not only by his physical surroundings but by his own nature and by the events and conditions of his life. It would surprise few familiar with Pratt's geometricized semi-abstract clapboard houses to learn that Pratt, whose father was a steel and hardware merchant and whose mother's family were in the lumber business, could gauge a two-by-four before he could read. But the same viewer might be astonished to learn that Pratt's earliest paintings gave virtually no evidence of the classical direction of his mature art. In those formative years, he was more influenced by the American romantic-realists like Winslow Homer and Charles Burchfield than the Precisionist artists whose style his work came to resemble.

Pratt's earliest artistic experiences were provided by James Pratt, his grandfather, a self-taught hobbyist who took up watercolour painting towards the end of his life and maintained a studio in his home during Pratt's teenage years. Other role models included his Great-Uncle Ned (E.J. Pratt), and his mother, Christine Dawe, whose competent, small watercolour of a Dutch windmill hung in the family home throughout Pratt's childhood. Christine studied art at school and this example of her work seems to have had significant impact on both Christopher and his younger brother, Philip, who became an architect and still maintains an interest in painting in watercolour.[2] During his last year at high school, Pratt began to paint. His first watercolour, a seascape, hangs in his living room. Painted in his bedroom, it depicts a scene recalled from childhood. From observing his grandfather, Pratt had picked up enough technical information to create a fresh and vital painting.

In the fall of 1952, Pratt entered Memorial University's Faculty of Engineering. In the spring of 1953, at age seventeen, he won first prize in Newfoundland's Arts and Letters Competition for his watercolour, *Shed in a Storm*, (1952-53), a melodramatic watercolour study of a seascape. Young Pratt drew inspiration from the romantic sense of the artist in relation to nature. Looking to the example of others artists, such as Albert Pinkham Ryder and Winslow Homer and the poetry of his uncle E.J. Pratt, he would search his own environment for a subject that would "correspond."

His principal sources were magazine illustrations, art book reproductions and a series published by the Metropolitan Museum of Art, to which his grandfather subscribed. The *Metropolitan Miniatures*, distributed by the Book-of-the-Month Club between 1947 and 1959, included more than one hundred albums and thousands of reproductions of masterpieces from American and European collections.[3]

Pratt spent the summer of 1953 detailing forestry survey maps for the government of Newfoundland. In September, he enrolled in pre-medical courses at Mount Allison University in Sackville, New Brunswick. His mother, a nurse, had always encouraged him to study medicine. Though his real interest was art, medicine gave him a viable reason to study at Mount Allison where there was also a school of fine art. With his strong interest in wildlife and natural resources, he thought he might become a biologist.

That fall, concurrent with his pre-medical studies, the seventeen year-old Pratt applied to become a special student for six hours a week of drawing and painting instruction at the School of Fine and Applied Arts. He had an interview and portfolio evaluation with Lawren Phillips Harris, then director of the school, and with several faculty members, including Ted Pulford and Alex Colville. Amazed at the youngster's "undeniable latent talent," Harris wrote Christopher's father a letter praising "the astonishing high quality" of these early efforts and urging the senior Pratt to allow his son to transfer from medicine to art: "In our considered opinion, he has an artistic gift far surpassing that of the usually fairly-talented student who registers for this institution's Fine Arts degree course."[4] Though Pratt apologized for his technical weaknesses, Harris dismissed this problem. "Technique (besides being a highly personal thing) is merely the means to an end — we all believe that your son's technique, though of course capable of development, is even now most remarkable." Never before had Harris recommended the transfer of a student from one faculty to another, but in this instance, he felt it incumbent upon him "with respect to your son's interest, talent and feeling in and for art."[5]

Though it is clear that Christopher was already serious about a career in art, he did not feel that he would have his family's support if he made such a decision. The Pratts believed strongly in the individual's need to be financially independent; art offered no such security. His father did not respond to Harris' letter and Pratt withdrew from the fine arts courses he was taking.[6]

In 1954, Pratt again won first prize at the Newfoundland Arts and Letter Competition with *The Bait Rocks*, a stormy watercolour of a Cape Shore tree clinging to a rocky precipice. He took a prize for poetry in the same competition. Pratt spent the summer working as a fisheries guardian at Pipers' Hole River and South East River, Placentia Bay. Paintings and drawings of this period reveal a Giottoesque treatment of rocks, which suggests that Pratt had been perusing the *Metropolitan Miniatures* series.[7]

When he returned to Mount Allison in the fall of 1954, it was to the Faculty of Arts. That year, Pratt won first prize in both the poetry and the short story category of the University literary competition.[8] He also began to date a fine arts student, Mary West, the daughter of New Brunswick's attorney-general. In the spring of 1955, for the third year in succession, Pratt won first prize at the Newfoundland Arts and Letters Competition for his watercolour painting (and another first for his poetry).

That summer he was employed at his father's firm, J.C. Pratt and Company, recharging fire extinguishers and writing up invoices. The experience convinced him that he could never enter the routine business world. As he explained to his father, for him, "Water Street was a one way street."[9]

By the time he returned to Mount Allison in the fall of 1955, his academic studies were of little interest. His principal activities were his duties as Chairman of the Junior Prom committee. That Christmas, under his direction, Mount Allison's gymnasium was converted into *Brigadoon*. Murals covered the walls and the ceiling was enveloped in a blue cheesecloth sky. At the end of the fall term, Pratt left the University and returned to St. John's to devote himself to painting.

Until then he had dared little, enjoying the praise of his peers and instructors, and the prizes that came so easily. Now he would test himself. He anxiously visited his grandfather in hospital that Christmas but to his surprise, his grandfather encouraged him. With his family's blessings and Mary's birthday gift of a book called *The Artist at Work*, he set up his first studio in his bedroom at the family house on Waterford Bridge Road.[10]

Rocks and Surf, St. Mary's Bay, 1952
watercolour

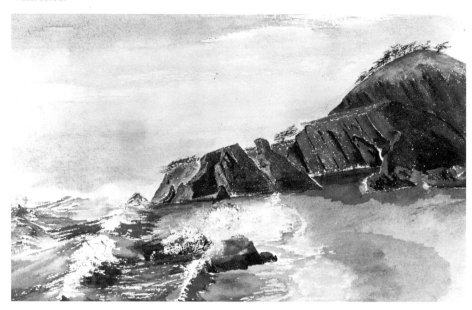

The Bait Rocks, 1954
watercolour

For instruction he turned to 1930s American artist, Adolph Dehn's *Watercolour Painting*, a gift several years earlier from his grandfather. Dehn's book was illustrated primarily with his own work, but it also included water-colours by artists such as Charles Burchfield, whom Pratt admired.[11] That year too, he acquired Norman Kent's *Watercolour Methods*.[12] These books would become important practical resources. From Dehn he learned to stretch watercolour paper, to work in wash, and to create clouds of wet paint blotted with tissue. Even his palette was determined by Dehn's advice. Dehn advised his students never to paint outdoors but to rely, instead, on imagination. On more than one occasion, Pratt composed paintings as responses to work illustrated in these texts.

Reinforcing Pratt's sense of the need for an indigenous artistic expression, Dehn praised Charles Burchfield for his "genuine American realism" and his lack of influence by European examples.[13] In Sackville, Pratt had heard crickets for the first time and identified the "buzz" of Burchfield's landscapes. There, too, he saw "farms that looked like Burchfield's farms, elms and a town with a main street and a sort of midwest look . . ."[14] In his St. John's bedroom/studio, these images combined with memories of Newfoundland as inspiration for his art.

One painting, of uncertain date, stands out from this period.[15] *South Side* is unlike any other work during these years. Probably influenced by Lawren P. Harris' abstracts and semi-abstracts, which Pratt had seen during the fall of 1953 at Mount Allison, the work reflects the "flat-pattern" exercises he had seen in classes there. Pratt was also familiar with the work of the Precisionists from magazine articles; and their influence, directly, or through the work of Harris, is very much present in this small painting.[16] Focussing on local architecture, *South Side* is strongly rectilinear and precise compared to the gestural handling of more characteristic works such as *Battery Road* (1956). A closeup view of houses, as if seen through a window — its simple handling, stylization and dominant frontality suggest the mature artist of ten years later. There were, Pratt recalls, several other works of this genre, one of a railway roundhouse.[17] Both Mary and his grandfather, whose opinion he so respected, found merit in these anomalous works.

Battery Road, 1956
watercolour

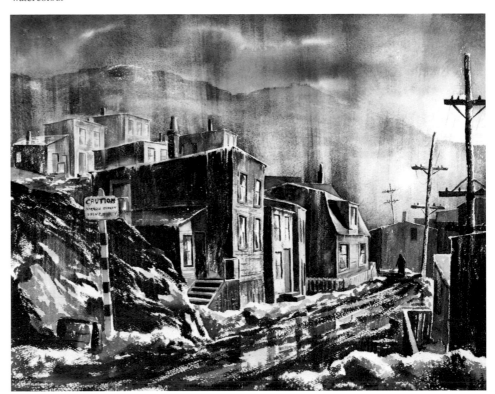

In the spring of 1956, Pratt's Aunt Myrtis took the nineteen-year-old artist, as her guest, on his first trip to New York. They stayed on Long Island, but spent their time in Manhattan and visited the Whitney, the Museum of Modern Art, the Metropolitan Museum of Art and the Museum of Natural History. Though he looked at the old masters and the impressionists, Van Gogh and the Douanier Rousseau, it was Winslow Homer whose work he particularly sought out. He recalls seeing Homer's *Gulf Stream* at the Metropolitan and asking a guard about other Homer works in the collection. But only two or three were on view.[18] The artist also recalls Edward Hopper's *House by the Railroad*, as one of the works that particularly struck him at the Museum of Modern Art.[19] At the Whitney Museum of Art, he was impressed by Charles Sheeler's work.[20] In New York, he felt like a "sailor in port". He loved the museums, particularly the Museum of Modern Art, but although he responded to the "strength and authority" of abstractions like those of Jackson Pollock and Mark Rothko, he felt such work could have no immediate lessons for him.

During the following year, the surging force of Homer's seascapes and the charged energy of Burchfield's landscapes were his models. In Rockwell Kent's graphic illustrations of Monhegan Island, Pratt found encouragement for images of a barren and windswept landscape and a coast line dotted with outport villages. Pratt purchased monographs on Winslow Homer and Charles Burchfield, books that would reinforce the ideas remembered from his New York trip.[21] As his work became more accomplished, relatives and friends were willing to purchase and to commission works from the gifted young painter, and Pratt became convinced that he could earn a living as an artist.

Pratt spent the year 1956-57 painting. The medium remained principally watercolour and the style changed little although the handling became increasingly competent. In the spring of 1957, he decided to enroll in the Glasgow School of Art. He and Mary would marry before they left. Christopher went to work as a surveyor for the contracting firm of Ayers, Hagen and Booth at the naval base at Argentia to earn money for the years of study ahead. The Pratts were married in Fredericton on September 12, 1957 and sailed from Halifax for Liverpool on September 14 en route to Glasgow.

NOTES: PAGE 80

Self-Portrait, 1958
graphite on paper

For, naturally, engineering made a strong appeal to the Scottish mind, so attracted by fundamental structural principles in building.

John Betjeman[1]

Though Pratt's decision not to study at an American art school had been deliberate, the decision to go to Glasgow was fortuitous.[2] The Glasgow School of Art sent him a warm and encouraging note about his work in response to his portfolio and he decided to go.[3] Glasgow was a congenial place for Pratt. He enjoyed the three-quarter-hour walk from his flat to the school; taking pleasure in the architectural facades that he passed en route. For an artist engaged by the wild country of Newfoundland, he found a strange affinity with this dark, gloomy industrial city with its grey brown buildings, its massive stones and its trams.

In 1947, an observer of the art scene wrote: "What was wrong with Glasgow was not that there was Academic Art (that is true of every town in every country) but that *in Glasgow there was only academic art.*"[4] Despite the importance of the New Scottish Art Group, founded in 1942, which sought artistic freedom and independence for Scotland, the foundation year education of the Glasgow School of Art when Pratt arrived in 1957 was much as it had been when the director of Pratt's first year course graduated in 1919.

(Jessie) Alix Dick taught foundation year at the Glasgow School of Art from 1921 until her retirement in 1959.[5] Her pedagogical approach reflected the academism that dominated the Glasgow School of Art. Pratt's school assignments from these years evidence the pervasive influence that Miss Dick had upon him and the development of his art. After their return to Canada, Christopher and Mary Pratt considered naming a daughter after her. More than ten years later, when Pratt received honorary doctorates from Memorial and Mount Allison universities, he attributed his success in large measure to Miss Dick.

Pratt recalls that he expected Glasgow to emphasize free gestural drawing. Instead he found that principal among the school's tenets was the importance of mastering established conventions through outline. In drawing class, the instructor brought in a carrot and "you drew it until you knew it. Then you drew an apple."[6] Finally the students graduated to drawing from casts. A weekly sketch book was kept, discussed and analyzed. Students were taught "how to look and how to draw to co-ordinate hand and eye."[7] "The more you refined it, the more you put into it, the better it was."[8]

When the student turned to the figure, he was taught to draw from a preconceived system of classic proportions that conceptualized the image in front of him. First he learned to draw the geometric forms; then, applying these forms as guides to the portrayal of the object, the artist drew from life. In the daily second-year life-drawing class, students exercised their understanding of these principles while the model held a single pose throughout the morning. Mary Pratt wrote her high-school geometry teacher to tell him how important geometry was in the education of an artist.

Glasgow taught Pratt to understand art-making in terms of concept rather than emotion, in terms of the ideal rather than the real, and in terms of the linear rather than the painterly. (Even the school's prospectus advised students to cultivate the faculty of drawing from memory and knowledge rather than from life.)[9] As Miss Dick frequently reminded Pratt: "Art is not reality."[10]

At Glasgow, Dehn's colour lessons were replaced by the Ostwald system and Pratt learned to blend colours carefully in accordance with its principles. His pictures were labelled "very American" for their subject matter and in their romantic and gestural handling. Watercolours were for Victorian ladies and his style was considered to be aggressively inappropriate for the medium.[11] *Grosvenor Crescent* (1957) was an exercise in a new approach to watercolour painting. Meticulously detailed, it lovingly caresses the cobblestones with a warm light. Unlike *Battery Road*, the street scene is portrayed parallel to the picture plane and instead of his earlier expressionistic handling, the watercolour medium is carefully controlled. This fresh direction was encouraged when he was singled out by the principal, Douglas Percy Bliss, who hung *Grosvenor Crescent* in the School gallery.

Though the Pratts had anticipated travelling and exploring Europe during holidays and the summer, Christopher decided to return to Newfoundland to work during the summer of 1958.[12] In the fall, their son John was born. The lessons of first year were consolidated during the next year in Glasgow. In assignments like the *Potato Peelers* and in studies for a family self portrait, Pratt experimented with expressing deeply felt emotion in figurative compositions, but this was a short-lived phase. When fellow students exhibited an interest in Tachism, in vogue in Europe, Pratt had little sympathy with them. He was being drawn increasingly to the conceptualizing principles he had begun to absorb. There was a satisfaction inherent in the process of making these carefully conceived and executed works.

Pratt remained at Glasgow for only two years. Yet the impact of the Glasgow experience on his work proved to be the foundation upon which his art would be built.

NOTES: PAGE 81

When Christopher Pratt returned to Mount Allison in the fall of 1959, he had completed two years of intensive study in the Glasgow School of Art's foundation programme. He also had three years of undergraduate university education and a year and a half of self-directed study in art. Yet the decision to stay in Canada was very much a last minute one. Encouraged by Lawren Harris, Pratt weighed the advantages of studying in Canada rather than in Great Britain. On graduation, Christopher would have greater access to the Canadian job market. Mary had obtained her certificate in Fine Arts from Mount Allison two years earlier but had not continued her formal studies; now she could finish her degree. It meant saving the expense of trans-Atlantic voyages and it offered Pratt new artistic freedom. Harris proposed that, in light of Pratt's proven ability and prior experience, he would be given access to all facilities and studios though he would not have to attend classes.

Responding again to Sackville, Pratt's first paintings and prints at Mount Allison evoked, on an even grander scale, the dramatic Burchfield-like expressionism that had characterized his pre-Glasgow work. Decaying houses (*House at Bareneed*), tortured trees (*Aspect of Point Lance*) and moonlit graveyards (*Cape Shore Cemetery*) proffered little evidence of the conceptualized approach that he had learned in Glasgow. But within a few months, his style had changed dramatically.

Aspect of Point Lance, 1959
oil on canvas

House At Bareneed, 1959
ink on paper

Photograph by
Christopher Pratt, 1959

Two artists' styles and temperaments dominated Mount Allison in the late 1950s. The tension between them was palpable to faculty and students alike. While Alex Colville's "magic realist" style derived directly from Renaissance traditions, Lawren P. Harris addressed modernist concerns in his geometric abstractions.[1] Dramatically aware of the importance of these issues, Pratt began to search for his own artistic voice. In Harris' assignments, he learned to abstract from nature; the gnarled and twisted trees of earlier work were replaced by the abstracted linear structure of the trees themselves. He came to understand his intuitive sympathy for the linear and geometric. But in works like *Sheds in Winter* (1959-64), *Haystacks in December* (1960), and *Boat in Sand* (1961), he rejected abstraction for images that conveyed his memory of Newfoundland.

Although he recognized that pure abstraction was not for him, Pratt also rejected the descriptive narrative of Colville and its "assertion of the fundamental reality of the external world."[2] Instead, selecting an image of strong personal significance and seeking the life of the object itself, he distilled its essential qualities and eliminated references to the specific or local. Pratt's mentors became those artists whom he felt had achieved a similar effect. On his bulletin board were pinned Edward Hopper's *Early Sunday Morning* (1930), and *Manhattan Bridge Loop* (1928) and Lionel Lemoine Fitzgerald's *Doc Snider's House* (1931).[3]

Drawn to the possibilities of silkscreen, Pratt took the equipment home and began to experiment with the process. He found the medium ideally suited to the methodical structuring of an art work that he had learned in Glasgow. Pratt never used cut or transfer stencils. He built images such as *Haystacks in December* and *Boat in Sand*, meticulously and painstakingly, making stencils directly on the screen with a small sable brush and dilute glue, seeking perfect alignment in the registration of the numerous screens. The final image, pared in detail and carefully controlled, was simple, strong and effective. The colours were cool and muted by the layering process with an emphasis on a clean linear style.

Studies for *Sheds in Winter*, 1959
ink, graphite on paper

Sheds in Winter, 1964
silkscreen

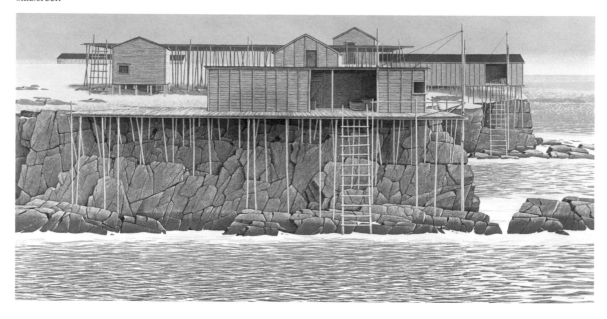

Haystacks in Winter, 1960
silkscreen

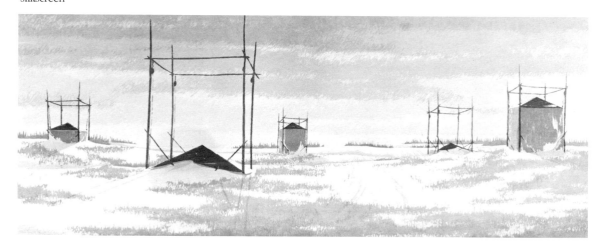

Semi-abstract study
based on *Haystacks*, 1960

Photograph by
Christopher Pratt, 1959

It was at Mount Allison that, for the first time, Pratt applied a preconceived geometric structure to a painting. *Euclid Working* (1961), is a *double entendre*. The truck is a "Euclid" and Pratt's composition is based on Euclid's theorem and the proportions of the golden section.[4] Pratt had studied perspective and had used geometry in constructing compositions in Glasgow, but he had never before premised a composition upon a coherent system of measure.[5] Though the proportions were altered in the final painting, the harmony of this ancient proportional system would become an essential aspect of Pratt's art.

While still a fourth-year student at Mount Allison, Pratt began to receive recognition for his work. His *Boat in Sand* was selected by Russell Harper for the National Gallery of Canada's Biennale and was later purchased for the gallery. In the spring of 1960 *Haystacks in December* was included in the "Young Contemporaries" show in London, Ontario. Pratt was invited to be a juror at the next annual exhibition. In the spring of his graduating year, *Demolitions on the South Side* won second prize at the Atlantic Awards Exhibition at Dalhousie and was purchased by the Dalhousie Art Gallery.[6]

When Pratt graduated from Mount Allison in the spring of 1961, he assumed the position of Specialist in Painting and Director of the Art Gallery at Memorial University. Everything had gone as he had wished. But the instant success he achieved gave him as much cause for worry as for rejoicing. Never entirely certain of his own ability, he wondered whether his success was deserved or whether he had been singled out principally as the logical representative of Canada's new tenth province. The concern remained, and it seems clear that Pratt's constant purifying and abstracting of imagery in future years was, to some extent, an attempt to ensure that his work would not be misunderstood or valued only for its identification with a particular place. Making universal statements from local experience would become Pratt's consuming passion.

NOTES: PAGE 82

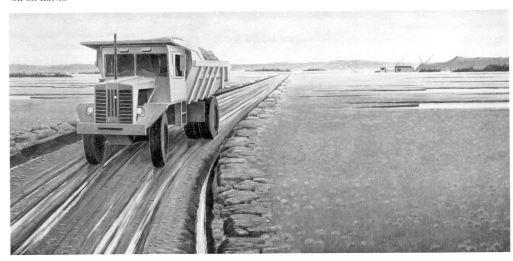

Euclid Working, 1961
oil on canvas

Basic $\sqrt{5}$ rectangle

$\sqrt{5}$ rectangles

Grosvenor Crescent, 1957
watercolour

Looking back,
I can't remember if
it was an evening late in spring
or early in the fall
except
that it was warm
and it had rained;

and when the light was gone
the darkness made
a soft and silent room
so close around us
that
we were its walls.[1]

Architectural imagery has proven to be the most complex and enduring theme in the art of Christopher Pratt. Although the "Precisionist" little gouache, *South Side* offers an uncanny foretaste of his later work, Pratt's early architectural imagery consisted of expressionistic cityscapes like the 1956 watercolour, *Battery Road*, which owes its compositional strength to lessons well-learned from Adolph Dehn's *Watercolour Painting.*[2]

As a student in Glasgow, Pratt's subject matter was often prescribed, and, on several occasions, the assignments pertained directly to the urban environment. Moreover, Pratt's fully developed work preserved from this period is architectural in subject. Though his living conditions were less than ideal and pollution was heavy that year, Pratt found excitement in the dense and complicated structure of the city. On his daily walk to and from school, he became fascinated with the massive architecture and pondered the life beyond the veiled windows.

Like Edward Hopper, whose *Early Sunday Morning*, and *Manhattan Bridge Loop*, he had pasted into his scrapbook before he left Canada, in works such as the watercolour, *Grosvenor Crescent* (1957), Pratt reflected upon the nature of urban living.[3] Through the use of partially drawn shades and different states of interior illumination, he alluded to the private activities of the city's residents. Most certainly, the order and control implied by the continuous facades appealed to him, as did the carefully constructed stone walls that bordered the fields of the Scottish countryside. For Pratt, they represented the imposition of man's control upon the natural environment — a powerful contrast to the desolate barrens of Newfoundland's Avalon Peninsula where man's presence had no enduring impact.

South Side, 1953
gouache

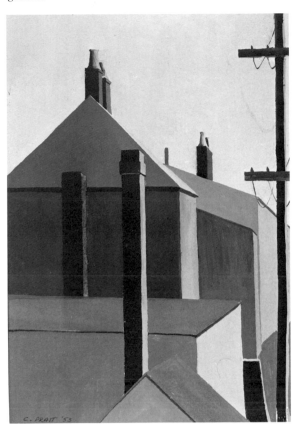

Edward Hopper, *Early Sunday Morning*, 1930 oil on canvas
Courtesy: Whitney Museum of American Art

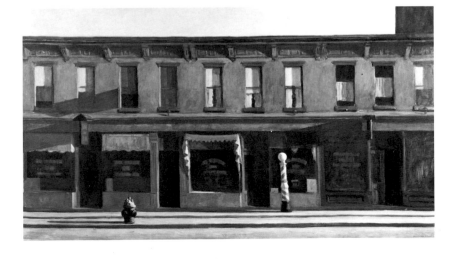

Comforted by the solid blocks of flats, he made them his subject. But Pratt seems also to have understood the illusion of their evident permanence and durability. In Glasgow he became aware of the painting of James Morrison, whose work included not only views of Glasgow streets but the demolition of those erstwhile solid blocks of granite.[4] Two years after his return from Glasgow, in the gently rolling hills of Sackville, Pratt painted his first major oil painting, *Demolitions on the South Side*. Ostensibly based on a scene in St. John's, *Demolitions* owes as much to James Morrison and slides that Pratt took of a demolition site in Glasgow as it does to the specific reality of St. John's. As in all his other street scenes, the image began as a view of a building-lined street that angled easily off into the composition. But in the process of creating this painting, it seems fair to say that Pratt radically revised his aesthetic philosophy.

Aware of the powerful impact of Hopper's lonely urban scenes, Pratt moves, in *Demolitions on the South Side*, from expressionism and description to an almost surrealistic street scene empty of human presence. The preliminary works move from the romantic and painterly handling of earlier urban landscapes to a radicalized simplification and virtually anonymous stroke. The more freely brushed contours of *Battery Road* are replaced by sharply ruled lines. The angled street of earlier works is pulled dramatically forward until the entire scene is viewed frontally, parallel to the picture plane.

The change can be attributed principally to the influence of Lawren P. Harris, who had made Pratt acutely aware of the concerns of the modernist painter. In his writing, his teaching and his art, he was a fervent advocate of abstraction. Pratt wanted to make art that was about the act of painting — about the flat surface, the shape of the support and the properties of pigment — but he did not want to give up recognizable imagery. At Mount Allison, he set out to integrate the two apparently antithetical goals.

Familiar with the mathematical foundations of Renaissance art, Pratt became engaged by the classical ideal and measure as a solution. In devising an abstract mathematical structure to carry his imagery and in emphasizing the frontality of the picture plane, Pratt discovered that he could mitigate the quality of illusion in a representational scene. He found a model for this exercise in Paolo Uccello's *Battle of San Romano* (c. 1450) in which the emphasis on perspective and on the single vanishing point create the "artificial appearance of a stage."[5] The treatment of the debris in Pratt's preliminary drawing

Study for *Demolitions on the South Side*, 1960
graphite, ink on paper

number 14 for *Demolitions* reveals that he has examined the careful perspective rendering of the broken lances in the foreground of Uccello's work. Though omitted from the final painting, this detail records Pratt's fascination with the underlying mathematical premise of the composition. In the end, Pratt found the rigorous system of perspective contrived and opted for a more intuitive arrangement of formal elements, conforming his use of colour to the ordered, geometrical requirements of the composition's design in a conscious attempt to eliminate the picturesque. *Demolitions* was an important step in Pratt's resolution of the relationship between form and content, and the resulting "constructed" art work was crucial to his artistic development.

When, in 1961, Pratt premised *Euclid Working* on a golden section root five rectangle, he consolidated his effort to find an appropriate framework to unify form and content into a conceptual whole. Though perspective remains a vital organizing factor in this painting of a truck moving into the viewer's space, proportional relationship is the dominant element in this work.[6] For the rest of his career, Pratt would seek in his work the abstract, geometric ideal.[7]

Demolitions on the South Side, 1960
oil on canvas

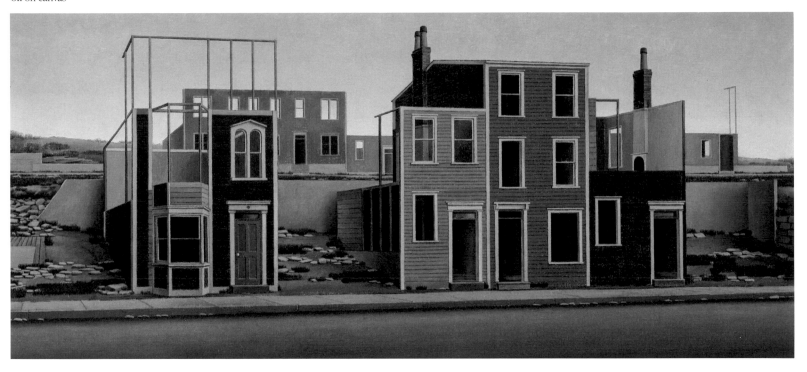

James Morrison,
Derelict Tenements.

Study for *Demolitions on the South Side*, 1960
graphite, ink on paper

Study for *House and Barn*, 1962
graphite on paper

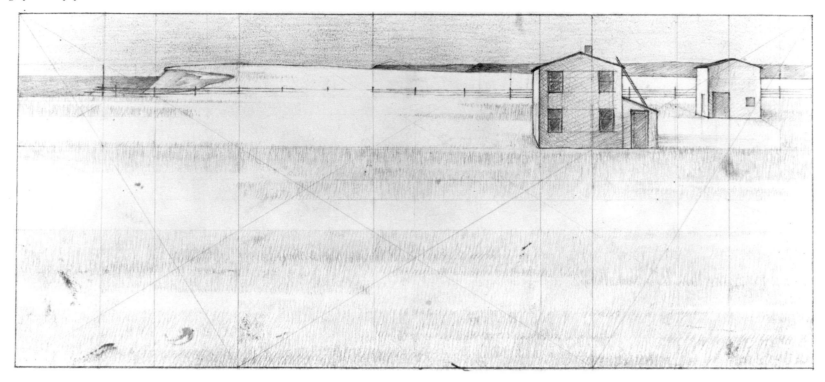

After his graduation from Mount Allison, Pratt moved to St. John's to assume the post of Specialist In Art at Memorial University. In addition to running the art gallery, he was required to teach in the University's extension programme. The workload was onerous, the teaching offered few rewards and there was little time for his own art.

Feeling trapped and frustrated, Pratt painted a work that would become central to his experience during the next twenty years. *House and Barn* (1962) portrays two buildings set in an open landscape.[8] Distilled through memory, ordered by mathematics and controlled in tonality and light to suggest atmospheric conditions and time of year, this image represented the essence of Newfoundland. Against the winter landscape, the protective geometry of the house offered solace for the artist's troubled soul. In both his poetry and painting of the period, Pratt strove to name and define the Newfoundland experience.

There are, suggests Gaston Bachelard, two kinds of geographical space: there is architecture and there is the universe beyond. There is the house and the non-house.[9]

For Pratt, the experience of Newfoundland was in its geography, its climate, and its light, and most of all, its architecture. Many years later, Pratt said of *House and Barn*:

". . . at a very unhappy period in my life, I dreamed of moving to some remote headland, of being able to see this kind of house out of my window: the archetypical house. I've been painting [it] ever since. The snow along the grass and the light coming from the same direction as the wind give a sense of movement and exposure, of the sweep of wind coming in off the sea."[10]

For Pratt the simple clapboard houses of Newfoundland came to denote both physical shelter and psychological refuge. Formally they offered a subject eminently suited to his stylistic concerns. In their precise geometric forms, they represented not only the historical roots of American art and architecture but the most modern characteristics of each. As Vincent Scully has argued, the history of American art and architecture may be defined by a pervasive instinct towards a precisionist vision.[11] Equating precisionism with purity of shape, linearity of detail and compulsive repetition of elements, Scully

argues that four related kinds of precisionism may be distinguished in American architecture: precision of surface, of mass, of plane and of structure. Although the domination of architectural precisionism is most clearly manifest in the "American screen-wall" of the mid-twentieth century, the formal properties of that wall and the impulses that govern its design can, he suggests, be discovered in some of the earliest buildings constructed on this continent.

The architectural features by which Scully characterizes the early American house, the direct antecedent of the clapboard homes that dot the Newfoundland landscape, are the subject of Christopher Pratt's painting. Sheathed against the winter, they "ride the land like a ship." Distinguished by flat planes and thin crisp lines, Pratt's imagined house, like its antecedents, is a "taut, hollow box, closed against everything external to itself . . ." Such structures afford not only refuge but their simplicity and purity of form embody the Puritan conversion of the fear of isolation and embattlement with nature into "the positive desire for an ideal, abstract creation in which contact with nature and the thicknesses of matter are alike eschewed."[12]

The precisely painted, dramatically taut clapboard screens of Pratt's later works, *House in August* (1968), *March Night* (1976) and *House at Path End* (1979), reflect the same aesthetic concerns. In each of these works there is the house, and the universe beyond the house: in Pratt's paintings, the confrontation between them is a vital force. Pratt's modernism would have been understood by his ancestors as he has understood their architectural Puritanism: "to be abstractly exact and ideally perfect."[13]

Rudolf Arnheim has argued that artistic form "always points to something beyond itself." Simple images, especially, must contain structural correspondence between meaning and tangible pattern.[14] That the compositional device of the golden section offers an appropriate visual equivalent to the idealized meaning of *House and Barn* cannot be doubted. The repeated boxes of *House and Barn* stand like sentinels in the landscape. Like the modern abstract artist and the Puritan architect, Pratt creates an affinity between the emotional and pictorial expression. Into the idealized archetypal image of home, Pratt has integrated design, handling and subject matter in a united whole through the repeated use of the golden section. (Working drawings reveal that the grid that underlies this work is based upon a central square with a golden section rectangle on each side. Within that

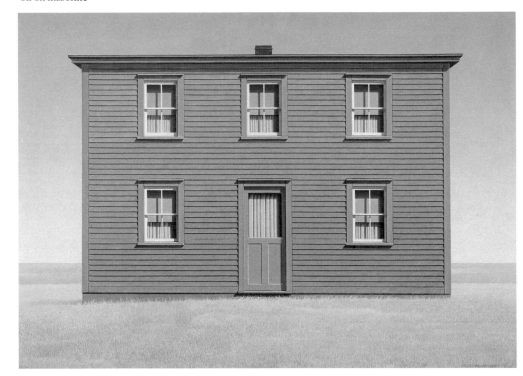

House in August, 1969
oil on masonite

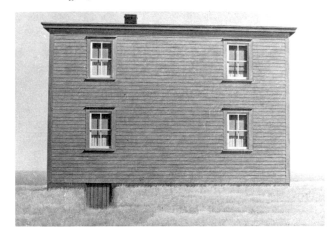

House in August, Interim State

composition further squares and golden section rectangles are created by the horizontal formed by the base of the large house, its shadow to the right and the snow line to the left. Each of the upper rectangles also forms a square and another golden section rectangle. The dividing line runs along the chimney of the house and through the barn.)[15]

In 1968, Pratt painted *House in August*, his archetypal house, like no house he had seen and like every house he had known. This image underwent a continuous refinement.[16] Initially, Pratt had chosen a back view of the house, but despite the strength of the continuous clapboard, the absence of a door bothered him. The final house is rigidly symmetrical, the ideal house of the childhood dream, manifest. The house is closed and curtained against prying eyes, its solid structure reduced to the two-dimensional sharpness of the clapboard screen. Pratt has described it as "a sense of a kind of person, a sense of a kind of place, a sense of a kind of situation . . . I get a sense of myself. The process is an act of research into one's own humanity. That's what the creative process is. You are researching a humanity, and the only humanity you have total access to is your own."[17]

Only occasionally did Pratt stray from refining and abstracting his architectural imagery. In 1968, as if debating his course towards the abstract, Pratt painted *Tessier's Barn*. This work, like that of Andrew Wyeth and Charles Burchfield, explores the picturesque and romantic aspects of the architectural image. Paint peels, shingles fall, the seasons pass: the timeless landscape of field and ocean are replaced by the temporality of deciduous trees. Yet this was merely a digression, for anecdote would have no permanent place in his work.

In 1963, Pratt left Memorial and moved to the family cottage on the Salmonier River to concentrate on his art. There, in a small clapboard cottage, Pratt continued his investigation of architecture as a means of exploring the nature of human existence.[18] His first major work from this period is the drawing *Window by the Sea* (1963).[19] There are six studies extant for the final drawing; in each the artist wrestles with the location of a single window within architectural elements suggesting the corner of a house. While proportion and harmony remain key elements in the creation of this work, the role of the window has changed dramatically in the year since 1962 when he drew a small, pencil and chalk drawing, *Window, January*. (Viewed from the interior of a building — the exposed rafters suggests a cabin — *this* window, echoing the larger rectangle of the composition, opens on to an

Tessier's Barn, 1968
oil on masonite

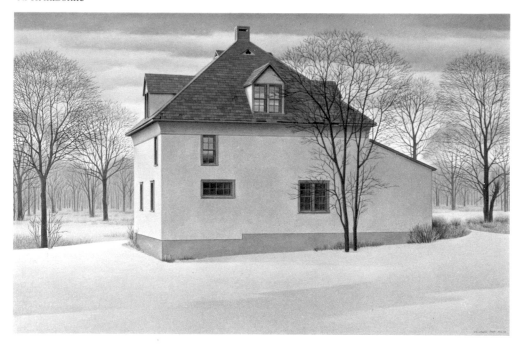

Odilon Redon, *The Light of the Day*, 1891
Courtesy: Art Institute of Chicago

Window, January, 1962
graphite on paper

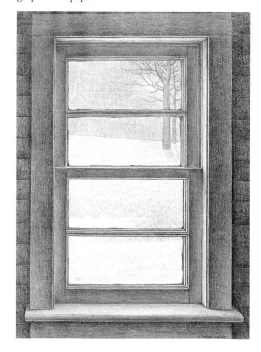

idyllic and simple scene: leafless trees, the moon, and a snowy landscape.)[20] In *Window by the Sea*, the window is not a logical device to extend pictorial space. Though the sea may be glimpsed through it, filtered through the oblique angle of a second window seen in perspective, the principal purpose of this window is containment. In selecting the corner of the house for the architectural focus, Pratt has added emphasis to the protective nature of interior place. Parallel to the corner of the house, in abstract rectangular segments capable of infinite expansion, the artist juxtaposes the sea and the sky.[21]

In *The Poetics of Space*, Bachelard suggests that, although the house is primarily a geometric object that by nature should resist "metaphors that welcome the human body and the human soul . . . transposition to the human plane takes place immediately whenever a house is considered as space that is supposed to condense and defend intimacy."[22] Through the "remembering" of our existence within houses and rooms, we learn what it means to abide within ourselves. In Pratt's paintings, architecture is metamorphosed into human experience and in portraying the image of the house as experienced through memory and imagination, Pratt awakens in the viewer his own experience of the house as our "first universe." If it is true that in losing contact with the house, we lose contact with ourselves, in Pratt's paintings we touch the poetic depth of the space of the house, "*one of the greatest powers of integration for the thoughts, memories and dreams of mankind.*"[23] *House and Barn, House in August*, and later, *March Night*, deal with the archetypal exterior of houses. In *Dresser and Dark Window, Trunk, Bed and Blind, The Bed, Three O'Clock, Cupboard, Flashlight, Sackville Attic* and *Pink Sink*, the experience of houses known in the past finds, through memory, the possibility of renewed life. None of Pratt's austere and dreamlike interiors is empty. Each reverberates with meaning and memory.

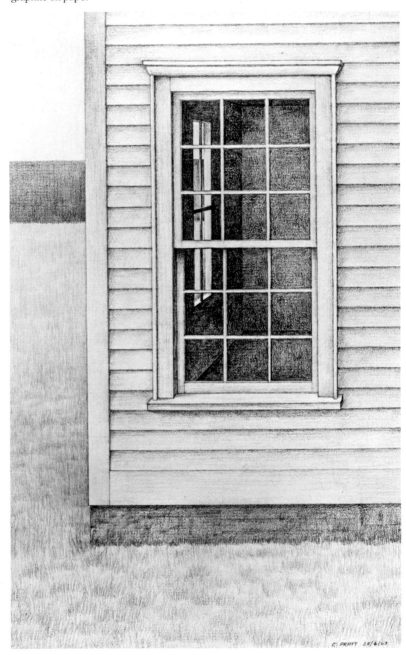

Window By The Sea, 1963
graphite on paper

In Pratt's exploration of the interior of the house, it becomes clear that each room and each area has its own psychological and spiritual implications. Pale green in a preliminary drawing, the brown wall of the painting, *Basement Flat*, suggests the earth colour of a subterranean dwelling. This is not the wall of the house of Le Marchant Road that the Pratt family inhabited until Christopher was seven; but it *is* the wall of the house as he remembers it. The cellar dreamer knows that the walls of the cellar are buried walls with a single casing: they have the entire earth behind them. The drama of Pratt's uniformly dark and frontal wall exploits the natural fears inherent in the dual nature of man and house.[24] Although the windows of some Pratt paintings open easily onto the cosmic landscape, we are forever imprisoned in this claustrophobic space.

Sackville Attic is every attic room. Access is through the lighter rectangle of the central "hatch." The slanted room and bare rafters offer shelter from the elements and a place that is secure. In basing his composition upon an equilateral triangle, Pratt echoes the solid geometry of the roofline. The lively blue grey of the print is suffused with the warmth of pink, the human presence. Here we are safe.

There is another aspect of the house that has engaged Pratt over and over again: the staircase. A look at how artists whom Pratt admired made stairways the subject of their work, shows us clearly what Pratt's stairways are not. Charles Sheeler studied the stairways of the Doylestown houses in his "American Interiors" for their design, for their reflection of the craftsman's pride and because of Sheeler's identification with the aesthetic goals of the Shaker craftsmen who fashioned elegant and perfectly harmonious works. In his stairwells, Pratt eliminates the details of craftsmanship and beauty that so appealed to Sheeler. Edward Hopper's stairways have, perhaps, a closer affinity. However, in Hopper's 1925 *Stairway*, we are positioned midway in our descent.[25] Below, a door opens onto a landscape that seems, through the similarity of interior and exterior colour, to impel us towards it. Hopper suggests a moment locked in time and demands our movement from interior place to exterior space. In works such as *Landing*, *Window on the Stair* and *Light from a Room Upstairs*, Pratt implies timelessness and dreamlike interiors removed from the external world.

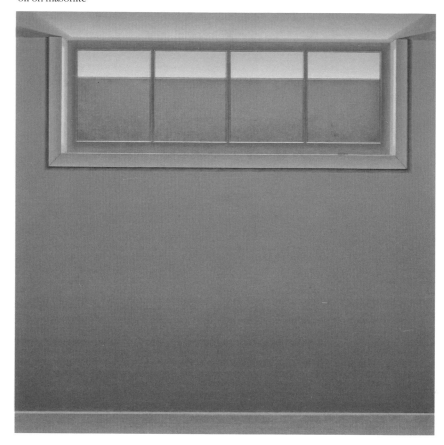

Basement Flat, 1978
oil on masonite

Sackville Attic, 1982
silkscreen

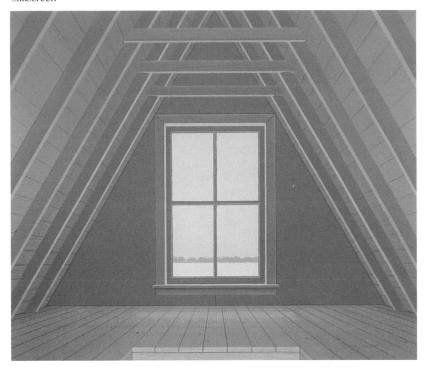

Light from a Room Upstairs, 1984
oil on masonite

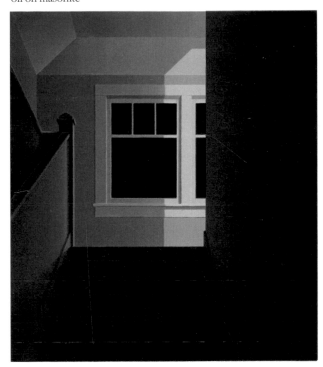

Landing, 1973
oil on masonite

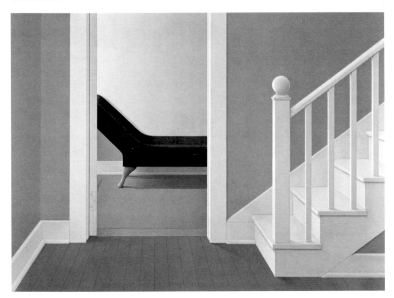

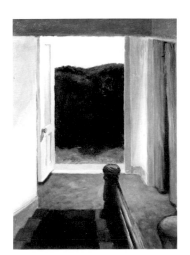

Edward Hopper,
Stairway, c. 1925
Courtesy: Whitney Museum
of American Art

Window on the Stair, 1969
oil on masonite

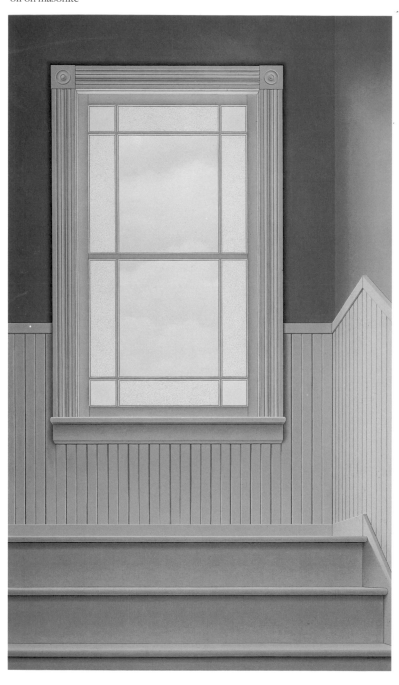

Northrop Frye has remarked that the stairway has been a recurring archetypal image in literature since Jacob's vision of a host of angels ascending and descending a stairway between earth and heaven.[26] For Bachelard, the stairway links the polarities of cellar and attic, and of the human psyche. As for Jung, the images of cellar and attic are used to analyze the fears that inhabit a house.[27] The remembrance of going down the stairs that lead to the cellar characterizes the nature of our dream. We go up and down the stairway that leads to the bedroom but we always go up the attic steps. Bachelard writes, "When I return to dream in the attics of yesteryear, I never go down again."[28] The attic bears the mark of an unforgettable intimacy perhaps even more than a remembered bedchamber. Like the tower in romantic novels, the attic is the scene of dreams.[29]

Within Pratt's oneiric house stand the chests and trunks of memory. Images of secrecy, they connect us with the daydreams of intimacy. By the time he painted *Young Girl with Sea Shells* in 1965, Pratt had discovered that no detailed description can adequately convey these daydreams, so the secrets of his trunks and chests are never revealed. The inner space of the containers portrayed in *Trunk*, *Flashlight* and *Dresser and Dark Window* is intimate space. These trunks and chests are not everyday pieces of furniture; so, "like a heart that confides in no one . . . the key is not on the door."[30]

Though the super-rational Pratt suggests that design requirements demand that doorknobs and handles be absent from such paintings as *House in August* and *Exit*, Bachelard's definition of the places so protected seems more convincing. It is for this reason that Pratt can remove such details with impugnity although he has noted that the key in the door behind Colville's *Woman in a Bathtub* (1973) augments the ominous feeling of impending danger. Pratt's paintings are images of absolute imagination where memory does not record duration; for we are unable to relive duration that has been destroyed. Thus no activity or threat can pass through these rooms. The compressed time of dreams goes beyond history. In such works space is everything.[31]

Dresser and Dark Window, 1981
oil on masonite

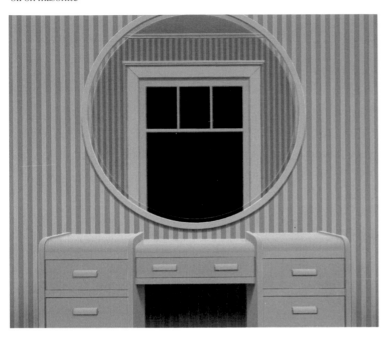

Trunk, 1979-80
oil on masonite

Flashlight, 1983
oil on masonite

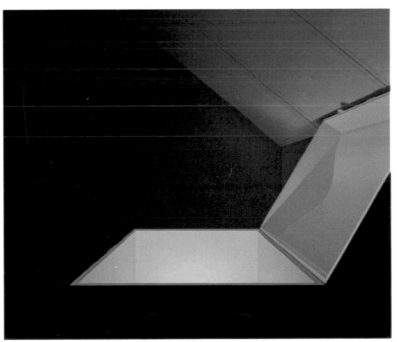

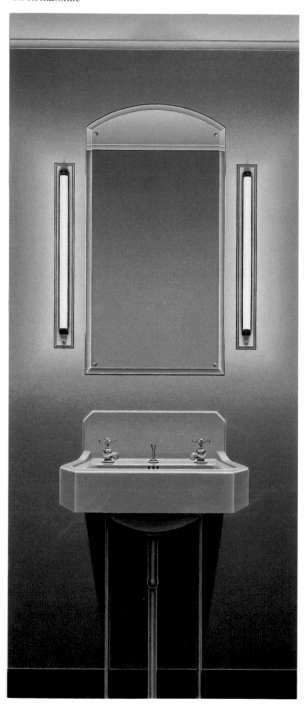

Pink Sink, 1984
oil on masonite

In 1976, Pratt painted *March Night*. Based on a double golden section rectangle, it is the ultimate asceticism of Pratt's architectural ideas. Like *House and Barn*, it is also a direct expression of human experience. One need only compare the solid boxes of *House and Barn* firmly located in the world of nature with *March Night's* synecdochic sheet of white clapboard against the darkness to understand the shift in artistic intention.[32] Although the flat plane of clapboard pressing forward towards our pictorial space is a recurrent motif in Pratt's work, no other work so reduces the wall to bare abstraction or establishes the tension between potential shelter and the void. (In *Wall Facing West* (1980) the transition from foreground building to background landscape is eased through the vertical treatment of the grassed area, the diagonal line of the roof, and the smoothly blended rosy glow of sunset. The frontality of *House at Path End* (1977) is accentuated by darkened windows and a rigidly vertical doorway, unbroken by even a doorknob; but the lamp post, its hidden light source breaking the intense gloom, implies a shallow ground by which to enter the pictorial space.) *March Night* offers no refuge. The sharp edge of its clapboard facade accentuates its Puritan sources and its precariousness. In the juxtaposition of architecture and nature — water, earth, trees and sky dissolve in the void of nocturnal gloom — Pratt establishes the dialectic between inside and outside. Sharpened by the starkness of the imagery, *March Night* embodies the dialogue between man and his world and reveals the existential duality of belonging and alienation.

In related paintings and prints, Pratt manipulates compositional elements through colour and tonality, adjusting design proportions. *Porch Light* (1972) meshes interior and exterior space through such compositional devices as the foreground step, the shadows denoting a space that the viewer may enter, the wave that curls towards us, and the subtle warmth not only of the sunset but of the circle of light radiating from the electric bulb. This exploration of man-made and natural light parallels that of house and non-house and of the reciprocity possible between man and his environment.[33]

March Night, 1976
oil on board

Coal and Salt, 1970
graphite on paper

St. John's Centre, 1969
graphite on paper

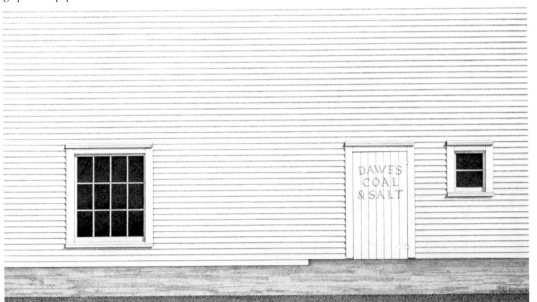

Between 1972 and 1973, Pratt created three other works incorporating a frontal clapboard wall in a dynamic relationship with the larger cosmos: *Sunday Afternoon* (1972) (the first totally frontal clapboard image), *Coley's Point* (1972) and *Good Friday* (1973). In each of these images, Pratt employs the device of the window. Blank, protected by a blind that totally obstructs our vision, the window in *Sunday Afternoon* offers insulation from the external world. In *Good Friday*, the open windows of the porch harmoniously integrate architecture and environment. Like the blind in *Sunday Afternoon*, the window in *Coley's Point* also precludes entrance into the interior space. By reflecting a landscape image in which the viewer is absent, the window negates, as it were, the viewer's existence. It is not a coincidence that Pratt initially intended this work as a memorial to his Dawe ancestors. He had thought to paint the door as if it were a coffin: hardwood, stained and varnished to look like mahogany with a small, glass nameplate bearing his mother's family name in silver.[34] The house, which held so many memories, reflects an admiration for its rich architectural features; yet it, like the past, remains closed to us. We are offered neither access to the house nor any transitional device that would allow us to enter the natural world beyond it.

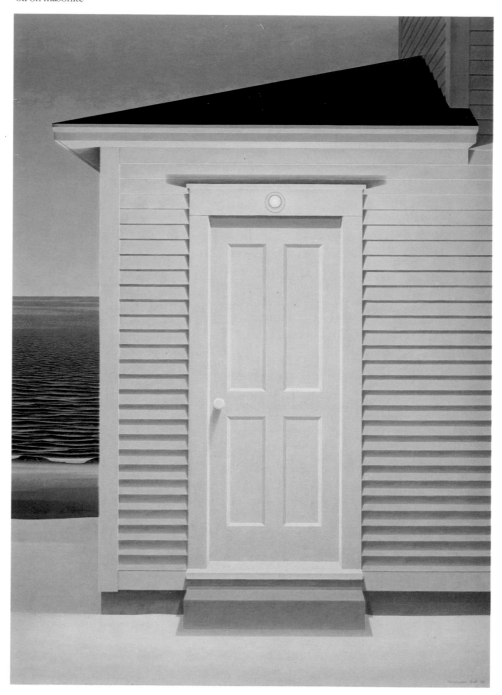

Porch Light, 1972
oil on masonite

Coley's Point, 1973
oil on masonite

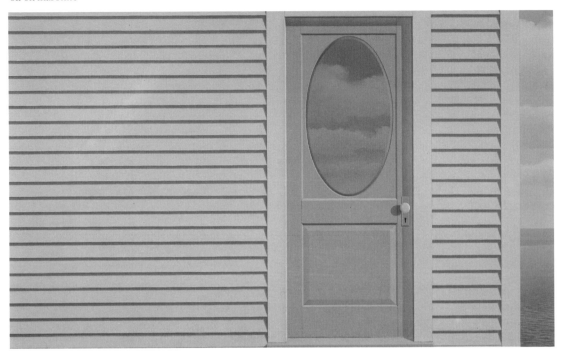

Shed Door, 1968
graphite on paper

Lighthouse Door, 1972
graphite on paper

Night Window (1971) is also a perversion of the window image. In an early conception, Pratt had envisioned a figure standing at the window gazing out into space. Rejecting the voyeurism explicit in Edward Hopper's *Night Windows* (1925) (Museum of Modern Art, New York), Pratt altered his final composition. He eliminated the model and placed the invisible spectator dramatically in the centre of the room. Just as he had rejected the filmy curtain motif linking interior and exterior so well used by Hopper, he now rejected (as he would again in *Me and Bride*), the concept of "exposure."[35] If the model were able to see out, she might also be seen. Instead, he opted for an interior view of the room, empty but for carefully calculated geometric images representing the reflections between window and mirror. Yet without a figure in the room, the careful calculations can signify nothing; we are locked in the centre of this empty and surreal space. It has been suggested that Pratt's poem "Night Windows" offers an analogy to this painting, but such is not the case.[36] While the poem envisions the window as a visual bridge uniting interior and exterior space, the painted window is a barrier to such interchange. This is not the space of later interiors, in which the world of memory engraves the image of a particular place in our mind. Rather, it is an anxious space, airless and illogical in which we are trapped, invisible between the mirror and the dark window.

Directly related to Pratt's domestic architectural themes, *Shop on Sunday* (1968) is an examination of Newfoundland outport life. The local store was a principal focus of these far flung settlements. In his childhood, Pratt visited many outport communities, and, during recent sailing trips around Newfoundland, he has often put in at one of these ports. In the deserted facades of local stores, the artist found gentle epitaphs in drawn shades and empty windows, for once-thriving businesses that had failed and communities that had died.

It is his life and the life of the community that Pratt commemorates in his storefronts and interiors. Though Pratt never paints a particular store or a particular village, he reconstructs their essence through the integration of design and abstracted subject matter. In the evolution of these images, we recognize the powerful capacity of poetic reality, filtered through memory, to surpass its specific sources.

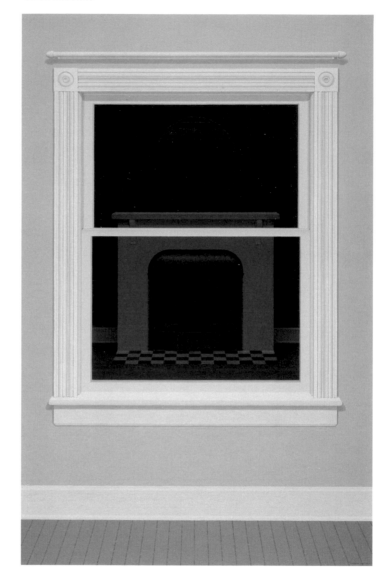

Night Window, 1971
oil on masonite

Shop on Sunday, 1968
oil on masonite

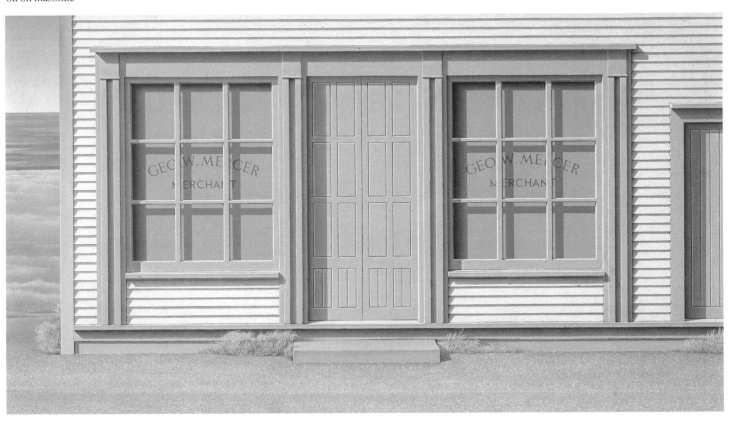

Studies for *Night Window*, 1971
graphite on paper

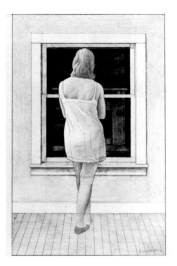

The watercolour, *Outport Business* (1964), reveals the place of these storefront images in the evolution of Pratt's work. Its clapboard facade is viewed frontally, parallel to the picture plane. Although the windows are empty and the blind is drawn, there is a handle on the door, the recessed doorway is protected, and the front step extends into our space to draw us in. Facade, grass, sea and sky are tonally linked in cool and muted colours.

In 1968, distanced by memory, that storefront image was translated into the oil on board, *Shop on Sunday*. Here the gentle articulation of surface is replaced by a rigidly frontal facade. Access into the shop is impossible; its window and handleless doors are forever closed. The composition echoes the sense of closure. The clapboard wall is pulled forward. Locked in the foreground space by the bifurcated door at the right and by the repetition of rigidly fixed right angles, it is divorced from the endless sea behind. Only the forlorn tufts of grass around its base link us with specific reality.

In 1969, Pratt painted his most powerful image of a store, *Shop on an Island*. One of his most abstracted designs, like the later *Whaling Station* (1983), this work converts the original artistic concept to a powerful image based on abstract geometric principles. Once again, poetic reality surpasses its origins and reveals larger truths. As the calm, stoic qualities of *March Night* can be attributed, in large measure, to the artist's compositional premise of the golden section; so, the dynamic tension of *Shop on an Island* may be traced to the artist's brilliant use of mathematical asymmetry. Logically, the centre of the central window pane in this work should also be the centre of the composition. However, Pratt makes the top left corner of the lower right window the centre of the image, which creates a complicated visual tension. Rhythmic patterns force the eye backwards and forwards and from side to side. Verticals offset horizontals; diagonals offset right angles; the closed offsets the open; and the linear and orderly offset the painterly and random. Even the intervals of the rhythmic pattern established in the railing closest to our space are interrupted by the verticals of the window frame behind.

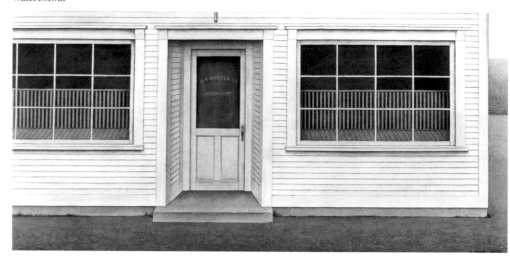

Outport Business, 1964
watercolour

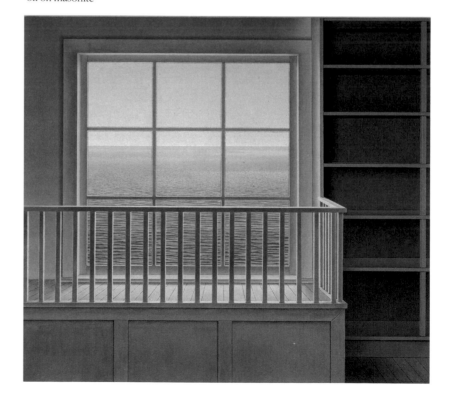

Shop on an Island, 1969
oil on masonite

For the first time Pratt uses the window, a metaphor for human presence, as a visual bridge between finite and infinite, linking the disparate realities he portrays. As a mathematical ordering device, the grid of the window organizes and contains the expanse of the ocean (in much the same way as does the relief in Michael Snow's construction *Atlantic*). Mitigating the lack of a middle ground that might have allowed us passage, that same grid reinforces the duality that exists between interior and exterior space. Structure, light and architecture serve as compositional coordinates between the world of man and the cosmos. Pratt's interior hues are muted and cool, contrasting with the roseate blend of pink and blue on the horizon; the internal light is controlled and low while external light is uniformally bright. Yet Pratt allows the thrust of light that penetrates the interior space to accentuate the connection between the two worlds. *Shop on an Island* extrapolates "pure form" from the factual reality of his subject matter.[37]

While it is true that all Pratt's paintings are determined by his Newfoundland experience, their subject is not necessarily Newfoundland. Since 1968 Pratt has done considerable work-related travelling, particularly to urban centres. The paintings, directly reflecting the impact of these new environments, reveal loneliness as do none of Pratt's other images. *Institution*, *The Visitor*, *Window and Blind* and *Subdivision* are all urban images, alien and alienating. Separated from the cosmic sense of place that is his in Newfoundland, Pratt is trapped in the artificiality of the urban environment. Skyscrapers have neither cellar nor attic: the height of the city buildings is purely exterior. Condominiums, apartments and even hospital rooms are geometric sites. With the box of the four walls, one may achieve safety from the elements but there remains no hope of attaining the cosmos.[38]

Michael Snow, *Atlantic*, 1967-80
Courtesy: Art Gallery of Ontario

Window with A Blind, 1970
oil on masonite

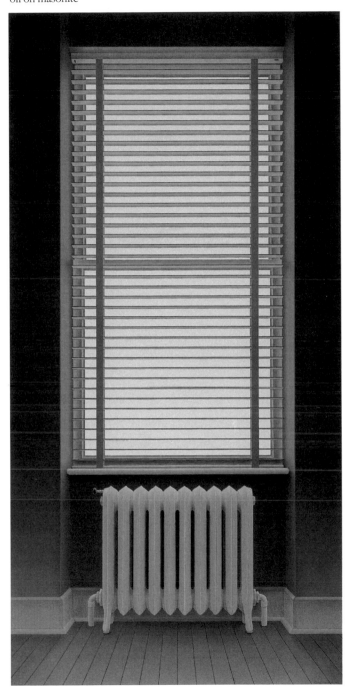

Station, 1972
oil on masonite

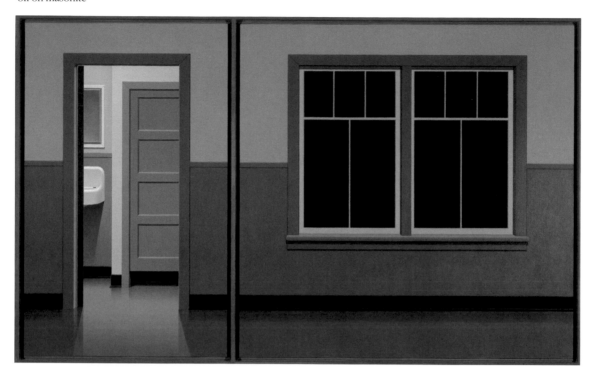

Study for *Station*, 1972
graphite on paper

Subdivision, 1973
oil on masonite

The strength of Pratt's urban images is their ordinariness. In them the human experience is expunged. *Window with a Blind* (1970) is without human presence. This emptiness is not the "emptiness" of Pratt's trunks and attics. They are full of inexplicable richness, and subtle pinks and reds infuse these paintings with the warmth of human presence. In *Window with a Blind* however, there is no suggestion of such warmth. The room is void of personal experience and memory. Spare and mathematically precise, the subject is the abstracted pattern created by the contrast of the heavy verticals of the radiator with delicate light patterns and horizontal armatures of the blind. But the blind is open and there is a faint glow of warmth penetrating this otherwise desolate and foreign space. Fourteen years later Pratt transformed the same motif to a more positive domestic interior in *Girl in a Spare Room* (1984). Here the figure is incorporated into a solidly integrated composition, including the apple-green walls of childhood memory. Light is almost anthropomorphized, integrating interior and exterior space and filtering through the venetian blind to mould and shape the figure.

Another "foreign" environment, *Station* (1972) resembles George Tooker's *Subway*.[39] Although Pratt's space is emptied of figures, it is permeated by the same claustrophobic imprisonment and isolation that dominates Tooker's work. In preliminary studies, a train bearing the CN logo could be seen through the window, but in the final work the window is dark, reflecting the shadowy interior space.[40] Unlike the reconstructed environments based on images recalled from childhood, spaces where duration does not exist, we are trapped, waiting. But the harmonious proportions of the underlying root five rectangle and the active, lively surface of the paint rescue the painting from utter despair.

Painted in leaden greys, the pessimism of *Subdivision* (1973) is unmitigated: there is not even a suggestion of human presence or possible relief. (Once more, Pratt overruled his early instinct to include a figure in the painting.) Even the *double entendre* of the title does not relieve the work of the overwhelming loneliness of its dark and viewless windows.

The hospital that served as the prototype for *Institution* (1973) is in St. John's. There, as a child, Pratt had his appendix removed; there, too, his father died. Yet the painting does not connote a specific site but the impersonal nature of institutions. It is about all those places that rob us of control over our destinies. Only the curl

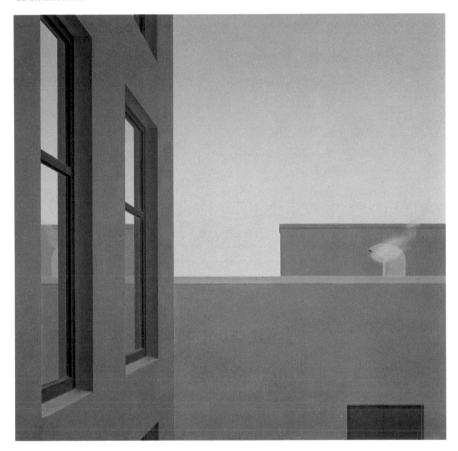

Institution, 1973
oil on masonite

of steam breathes life into the great, sterile and frozen environment inside and outside the institution. Unlike Edward Hopper's *Office in a Small City* (1953) in which the large picture window, admitting exterior light and space into the office building, united it with its environment, the blank reflective surfaces of Pratt's windows remain impenetrable; the anonymous lives behind the repeated windows of the urban skyline are not ours to share.[41]

Federal Area, 1975
oil on masonite

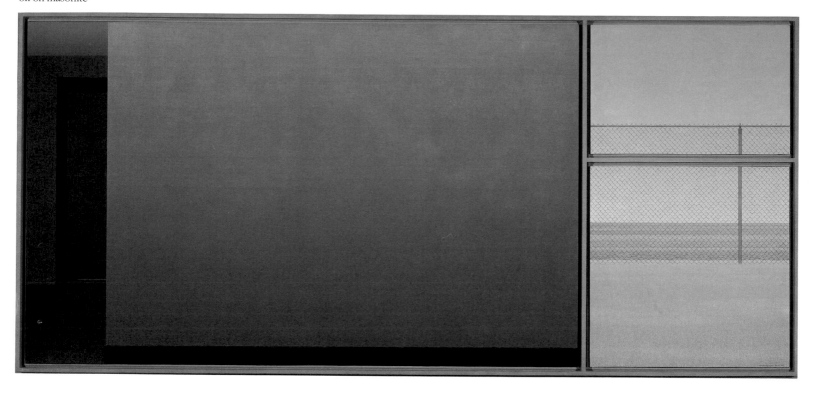

In the spring of 1957 Pratt worked as a surveyor in Argentia, the American naval station on Placentia Bay. He described the buildings of this former airforce base as "a monotonous uniform colour . . . you couldn't tell offices from officer's apartments. There were no trees; chain-link fences were strung along in the most improbable places — there was even one around the dump and one between the sea and the spruce forest." The physical oppression was matched by psychological pressures: "seething, almost ghetto-like . . . the experience informed my thoughts more than my paintings directly. I was taken by the idea of that sort of an institution, its physical oppressiveness and its indifference to human values."[42]

Inspired by Argentia, *Federal Area* (1975) is a painting in two parts. On the left is a large grey rectangle; another Pratt wall. Blended from light to dark grey with a rich combination of burnt sienna and cobalt blue with a touch of yellow ochre, it shields a handleless door and a dead-end corridor. To the right there is a pendant, its proportions determined by the root five rectangle. An abstracted window opens on a meadow and behind it is the peaceful sea. But relief is denied; passage to the sea is obstructed by a heavy chain-link fence. Abstract and representational elements are not integrated as they are in *March Night* and the impact of the confrontation between interior and exterior space is diminished principally as a result of the shift in scale from wall to window.

The Visitor (1977) is urban in its anonymity. Despite the absence of figure and emptiness of this boring and sordid room, there is human evidence, a pair of panties hanging on the metal heat vent. We are on a stage set and the drama will be played; but we know neither the play nor the players. The apparent simplicity of this triptych is a subtle understatement. Contrasts abound: the geometric grill of the radiator is set against the full, biomorphic handling of the lace briefs; the impersonal and mechanical are compared to the sensual and decorative. The window at the left offers its own opposites: empty and full, inner and outer, light and dark, open and closed.

The Visitor, 1977
oil on masonite

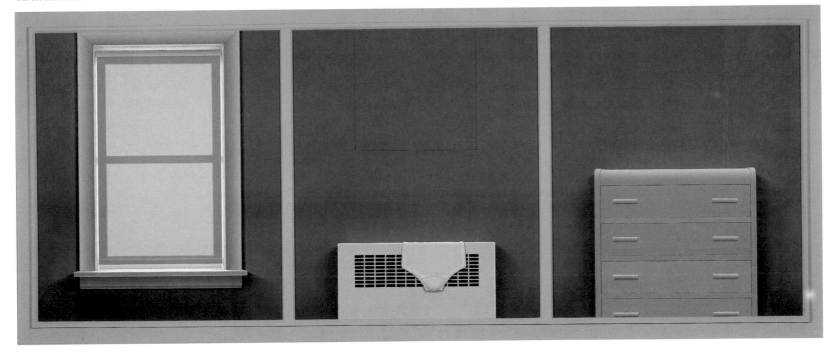

Works like these are both unsettling for the viewer and disconcerting for the artist. Asked to comment upon *Institution*, Pratt wondered if he had been "painting hospitals all his life: with [his] emphasis on crisp bare lines and clean walls."[43] Such, of course, is not the case. His smooth, precise technique, his sharp-edged simplified forms; and his emphasis on structural unity tie him to the Precisionists' search for a style to complement the technocratic society they inhabited. William Carlos Williams called his poetry *Imagism*. Seeking to speak directly in his art, like the phenomenologists, he sought neither meaning nor metaphor. Synthesizing the essence of his subject and structural unity, Pratt finds, as Williams had predicted, "pure form manifest in the reality of his subject."[44] Spareness of line, simplicity of mathematical structure and austerity of colour empower these works.

These urban environments are anomalous in Pratt's *oeuvre*. Their depersonalized spaces do not offer the refuge afforded by those evolutions from the paradigmatic house of *House and Barn*. The main body of Pratt's architectural imagery reaffirms Bachelard's view of the house as protective refuge and first cosmos; but the urban paintings are about marginality and alienation. Removed from the locus of his psychic ties, Pratt's anxieties and self-doubt increase. When he is away from home, Pratt does not paint; and it is in the act of painting that he reaffirms himself and his place in the universe.

NOTES: PAGE 82

Woman at a Dresser, 1964
oil on masonite

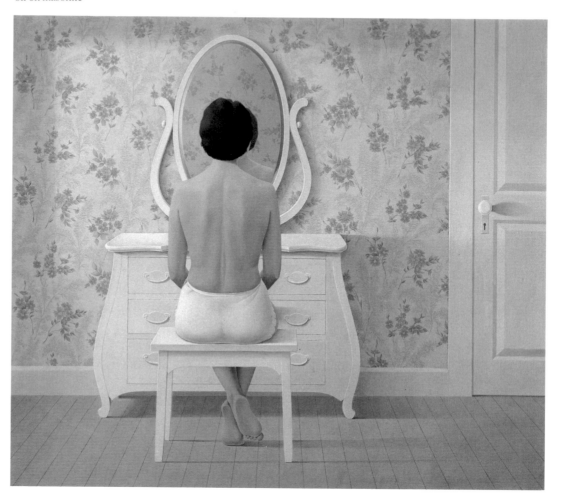

Although the figure had engaged Pratt's interest since his student days in Glasgow, *Woman at a Dresser* (1964), was the first painting other than his *Self-Portrait* (1961), the graduation requirement at Mount Allison, into which he incorporated the figure. The lack of a model had been a significant deterrent but with the move to St. Mary's Bay, Pratt took up the challenge of unexplored goals.[1]

On July 15, 1964, Pratt drew Doreen Ayre as a preliminary study for the painting *Woman at a Dresser*. The figure, seen from the back, is precisely drawn. Despite the casualness of the pose, there is an inherent sense of the monumental. The figure is clothed in underpants — the sitter was family friend rather than a professional model — but her clothing is not simply modesty. In still life and anatomy lessons at Glasgow, Miss Dick had taught the value of the section line as a means of defining volume and the lines around the waist and the thighs function in this way.

In a subsequent watercolour, *Study for Woman at a Dresser*, Pratt examined the problem of integrating the figure into an architectural setting and constructed cardboard maquettes based on childhood recollections of furniture that might have come from a 1930s Eaton's catalogue. Simple, white and lyrical in its curvilinear form, the lyre-like arabesque of the mirror echoes the contour of the woman's body and creates a counter-rhythm to that established by the legs of the dresser. To enhance the bedroom atmosphere, Pratt designed a wallpaper pattern, as he had many times in his Glasgow assignments. One more study, *Woman Sitting*, was required to adjust the proportions of the figure before Pratt began the final painting.

In *Woman at a Dresser* (1964), Pratt's original intention finds fulfillment. Every element works in harmony: figure and furniture are equal parts of the scene. By the time this work was complete, Pratt had found a young girl named Bernadette from the nearby town who would pose for him regularly. But the final version of *Woman at a Dresser* reflects neither Bernadette nor the original model, Doreen Ayre, any more than it represents a specific time or place. It is a poetic image, its source is memory. Detached from history, it lives in an eternal present.

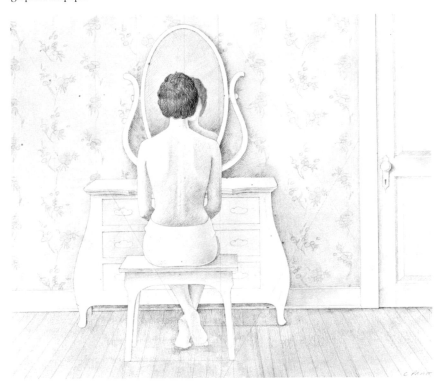

Study for *Woman at a Dresser*, 1964
graphite on paper

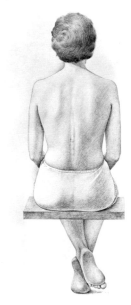

Woman Sitting, 1964
graphite on paper

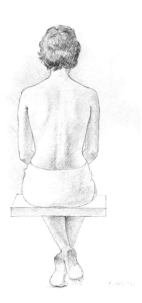

Woman Sitting, 1964
graphite on paper

In 1964 William Townsend of London's Slade School of Art toured Canada on behalf of the National Gallery of Canada to select works for the Gallery's Biennial. He visited Pratt and was genuinely moved by *Woman at a Dresser*, comparing it to the painting of Vermeer. Pratt, who had always doubted the merit of his work, was thrilled and encouraged. He was further reassured when CIL purchased the painting from the National Gallery of Canada exhibition.[2] During the next four years, Pratt painted his most successful figure paintings, all of them interiors.

Too timid in the afternoon
to run across the yellow fields
we hid behind the willow rows and watched
the small green apples ripen in the sun;

But when the early darkness came
secure and silent in the night
we raced across the meadow to the trees —

And in the lovely autumn nights
our happy fingers felt along
the blackness of the apple-limbs
until the bursting velvet fruit
filled up the hollows of our hands[3]

Pratt's second figure painting, his first based upon ongoing work with a model, was titled *Young Girl with Sea Shells* (1965). Complex in conception and derivation, the painting reveals the aesthetic concerns that would occupy the artist for the next twenty years. Despite the fact that paintings like *Young Girl with Sea Shells* are conceptualizations based on memory, the presence of the model is crucial to their development. Pratt sees the human figure, particularly the figure of the young woman, as a manifestation — perhaps the highest manifestation — of a natural order. By her presence, she ensures the continuity so important to creation.[4] In 1972, he wrote in his diary, "I believe there are a few basic forces or orders in nature that govern it and are present in everything, the animate and the inanimate, the real and abstract alike." Working closely, carefully and continuously from the model is essential for Pratt, not because he wishes to capture the character of his model — the subjects of his early paintings are virtually anonymous — but so he might better understand the essential structure of the archetypal ideal and find confirmation of the basic life force that pervades all of nature. Like Georgia O'Keeffe's flowers, Pratt's early figures admit no decay or imper-fection: these images are idealized neo-platonic abstrac-tions, synthesized to integrate the spiritual with the physical dimensions of his subject.

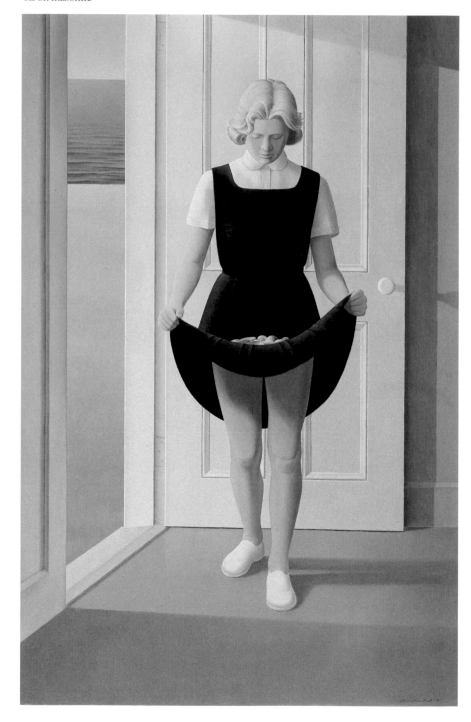

Young Girl with Sea Shells, 1965
oil on masonite

The preliminary work for *Young Girl with Sea Shells* was intended as part of a series embodying the rhythmic pattern of the seasons that Pratt was concurrently exploring in his poetry. A drawing of a boy returning from hunting across the snowy barrens, a rabbit slung across his back, exists for winter. The anecdotal serigraph, *Dipping for Caplin* depicts an activity associated with spring.[5] *Young Girl with Sea Shells*, the autumn subject, however, is far removed from the artist's first conceptions.

As is often the case with Pratt, the original of the image is an experience remembered from adolescence. In the nine studies for *Young Girl with Sea Shells*, a young boy and girl are portrayed stealing apples. The illicit nature of the act is heightened by the overtones of sexuality and the Edenic references implicit in the orchard setting and in their gestures. Depicted in front of a glade of trees or in some instances a single tree, the boy places apples in the girl's uplifted skirt. As the image evolved, it took Pratt farther and farther into the myth that displaces erotic love with apples.

Ultimately however, obvious analogies were unacceptable. In the final study the male figure has been removed, the girl's skirt is emptied of apples and the scene has been transposed from the orchard/garden. The setting, now an interior with access to the outside, is occupied by a single frontally positioned female figure, her face downturned, her uplifted skirt filled with sea shells. The once casual arrangement of figure and ground has been altered and locked into a composition based on the golden section rectangle.

It is interesting to compare this painting with Piero della Francesca's St. Elizabeth in the Perugia *Madonna and Child Enthroned, with Saints*.[6] In both instances the figures are clothed in a uniform that denotes innocence and purity: the brown nun's habit and a dark school tunic. Both female subjects, despite the frontal pose, avert their eyes from our gaze. Both hold in the receptacle created by their uplifted skirts, an assortment of shells — the symbol of order in nature and the attribute of the sea-born Venus. While there is no evidence that Pratt was consciously alluding to Piero in the conception of this painting, the preliminary drawings clarify the evolution of the work. As was often the case in the early Renaissance, Pratt has moved from the personal to the archetypal. Constantly simplifying and eliminating, he has excised the specific and the temporal in his search for mythic truths.

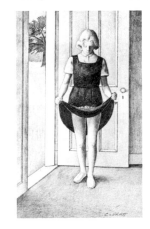
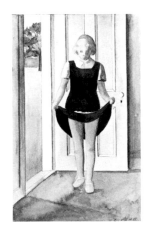

Studies for
Young Girl with Sea Shells, 1965

Piero della Francesca,
St. Elizabeth

As she had for Shelley in "Prometheus Unbound," the Venus figure with her skirt filled with shells, represents for Pratt, the archetypal muse (the generative principle of nature), the necessary complement of the artist/poet (the generative principle of mind). Together they are the coherent manifestation of a single productive force. It is their interaction that brings forth artistic creation; although the idealized Muse figure is the source of that creative inspiration.[7] Critics have complained about the anonymity and almost wooden character of Pratt's female figures. But in the paintings between 1964 and 1967, when his figures were the powerful embodiment of the Muse, specific characteristics or personal engagement between the artist and his model were irrelevant.

In the final painting, the child/woman, Bernadette, stands within the walls of an enclosed house. Behind the figure, through the open door, is the timeless sea, the light blending to the horizon. There are no specific signs of time or place. She remains forever on the verge of adulthood, ripe with promise. The artist has physically removed himself from the painting; for when two figures are depicted, incident occurs, time passes, and narrative is created.[8] The artist is spiritually present, however, and the communion between him and his Muse, the chaste figure of virginal youth that promotes artistic creation, remains inviolate.

For Pratt, Bernadette became the model who, by her presence, insured the contact so important to creation. Drawings took weeks of painstaking work despite their apparent fluidity. Paintings required her presence to confirm responses to lighting and modelling and, despite the fact that these were studio paintings set in an imaginary context, to ensure an appropriate interaction with the environment. Sometimes he cast Bernadette in the role of puberty. On other occasions, she became the *odalisque*, the reclining female nude. The model represented the artist's release from the memory of desires outgrown and the growth of a new vision symbolized by the Muse.

During the next three years, Pratt painted a series of figurative works which, though similar to *Woman at a Dresser* and *Young Girl with Sea Shells*, addressed a number of concerns that would become central to his mature work. Like his architectural images, with which they have a clear affinity, these works can best be understood within the context of localism — the theory of *place* established by American philosopher John Dewey and adopted by Imagist poet William Carlos Williams.[9] Williams believed that the American artist should pro-

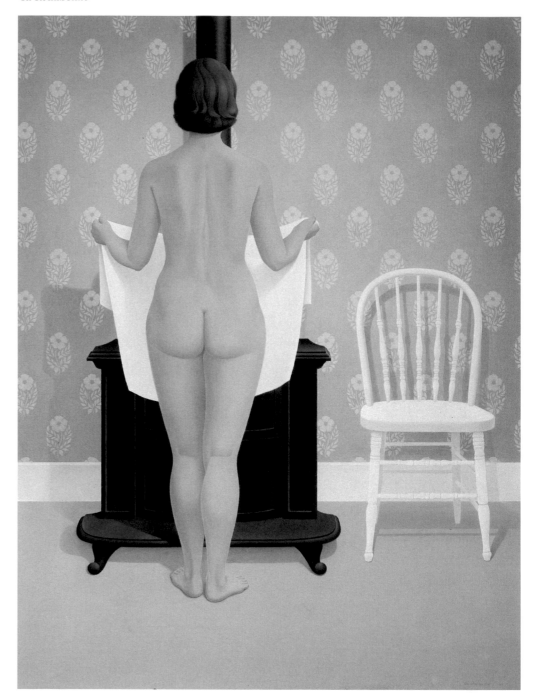

Woman at a Stove, 1965
oil on masonite

duce universals of general applicability — the "universality of the local." Fully cognisant of the importance of place to his work and to others' perception of it, Pratt realized that "regionalism", with its rejection of modernism and its narrow provincialism, was anathema to his aesthetic intentions. He consciously disassociated himself from regionalist implications and sought universal expression grounded in his own experience.[10] By means of geometry, simplification and repetition, Pratt would raise his images to universal signs, though they remained firmly rooted in his east-coast experience.

Working in the isolation of Salmonier, Pratt explored the essential "forces" of his environment, seeking to make timeless images from ordinary experience. He drew upon those artists, such as Hopper and Sheeler, in whose work he felt an affinity with his own. Sheeler's *Interior with Stove* (1932), was certainly the unconscious source for *Woman and Stove*.[11] The central image in both paintings is the black solid mass of the wood stove. The cut stump in Sheeler's image juxtaposes the biomorphic element of growth with the precisely finished edges of the fabricated stove, just as Pratt juxtaposes the texture and tone of the model's flesh with the hardness and darkness of the stove.[12] And as Sheeler looked to the material culture of his Shaker environment for subject matter, Pratt chose the familiar white open spindle back chair to contrast with the solid dark contours of the stove. Their work exhibited the same immaculate sense of craftsmanship. While Sheeler's was the result of his work as a photographer, Pratt's anonymous surfaces and sharply focussed edges were conditioned by the hard edge geometric abstraction he had experimented with at Mount Allison and by his experience in printmaking. Pratt offers a sparse, compact environment in which the details of daily existence are replaced by the almost surrealistic juxtaposition of objects. Art is neither mirror nor symbol of life. It is life "transmuted to a tighter form".[13]

At one point, recognizing the depersonalization of his figure, Pratt considered eliminating the central figure in *Woman at a Stove*, leaving only the chair and the stove. But she is, in fact, crucial to his conception and design. In his paintings, Pratt's women are not reflections of male desire or admiration. None of them can be construed as the object of devotion, lust or fear. (Even the voluptuous figure in *Young Woman Dressing* is deprived of sexuality by the perfect symmetry and frozen immobility of her position.) Instead they are part of the artist's concern to universalize the experience of familiar images.

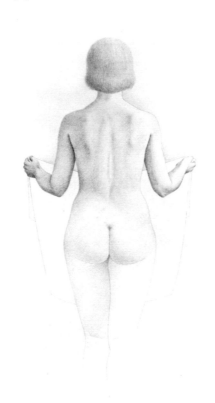

Study for *Woman at a Stove*, 1965
graphite on paper

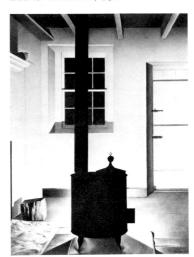

Charles Sheeler,
Interior with Stove, 1932

Composition is an essential element in this process, and it is natural that Pratt should have adopted the classical mode. With the absence of brush strokes, time stops and the moment is held in place — then locked by the mathematical ordering of planes in space parallel to the picture surface and by the deliberately aligned vertical elements. It is this conceptual approach to composition that places these paintings so firmly in the American tradition.[14] Williams wrote "without measure we are lost".[15] And Pratt has said, "I believe that things are better when . . . they're measured and held in check".[16] With his strong feeling for the linear and for the wholeness of objects contained within an orderly structure, Pratt has created direct contact between reality and abstraction through an intense concentration on the visual reality of an object.[17]

In the figure paintings, including *Woman and Stove* (1965), *Young Woman Dressing* (1966), and *Young Woman with a Slip* (1967), preliminary studies reveal a clear evolution. Pratt has constructed his environments by assembling elements to create a feeling of warmth, of familiarity and, most of all, of a recollected shared experience. In preliminary drawings the handling is gentle, the touch more immediate — the artist has begun with the model and her temporality. In the final work, we are confronted with hardened contours, and Pratt is uncertain of the success of some of the more awkward figures. Yet through similarities in colour and value and in the shapes of animate and inanimate objects, figures are so thoroughly integrated into the design that the paintings cannot function without them. It is the dominant concept of the paintings that has dictated the handling of the figures. Shedding sensuous line and gentle touch, Pratt makes his figures equivalent to the environment that they occupy — an environment that will both complement and reflect them in the shared experience of the universal and the local.

Santayana has suggested that the poet who, like Pratt, wishes to pass convincingly from love to philosophy should be a hearty and complete lover, neither personally restrained nor too given to fancy. He argues that when the love image or muse is extended platonically and identified with revealed wisdom we feel a suspicion that if the love in question had been more natural and manly, it would have offered more resistance to so mystical a transformation.[18] Pratt has never been reluctant to acknowledge the Puritanical aspect of his character.

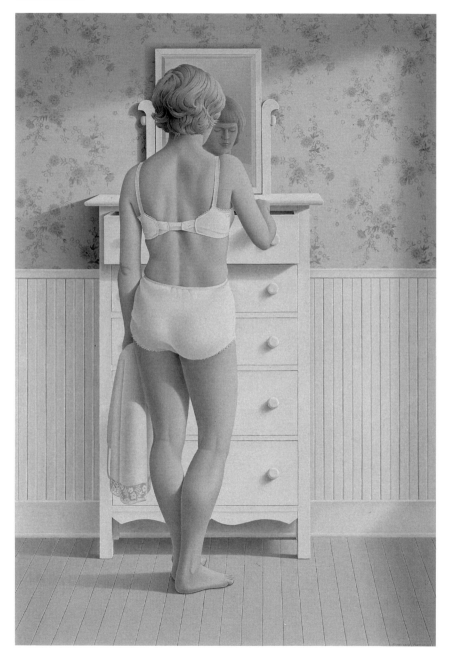

Young Woman with a Slip, 1967
oil on masonite

What then can be made of these early paintings? Are they, as Santayana implies, the natural outcome of repressed sexual desire? There is, without doubt, some truth to Santayana's analysis and Pratt's work most certainly represents the conflict within his own personality between Puritanism and sensuality; between woman as madonna and as temptress. In *Young Girl with Sea Shells*, Pratt's original desires were reborn in the pure and chaste form of the idealized Bernadette. And in subsequent paintings, the initial engagement with the model is transmuted into the aesthetic search for impersonal truths, both physical and spiritual. Painting becomes an investigation into the nature of matter and of creativity.

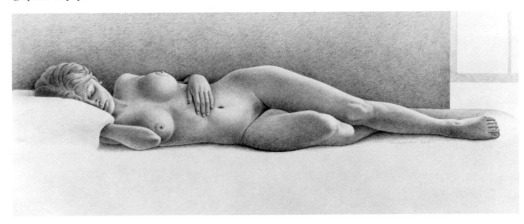

Nude Lying Down, 1967
graphite on paper

Study for *Young Woman with a Slip*, 1967
graphite on paper

Young Woman Dressing, 1966
oil on masonite

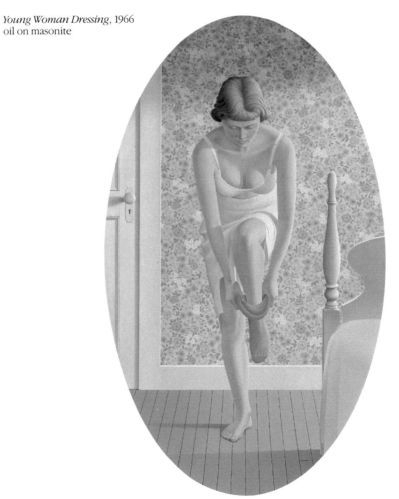

Between 1971 and 1973, Pratt had no regular model and did little figure painting, but in 1973, he painted *French Door* — a work that is in large measure a tribute to Donna Meaney, who had left several years earlier for Halifax, after three years as model and *au pair* in the Pratt household. Of Donna, Pratt has said, "I always felt that she was just on the periphery, endangered, exposed to our ideas, which were not viable for her. She was outside looking in. She wasn't part of our lives. But we were dominating hers — I saw that after she had left. I did the painting then."[19] Like most of Pratt's major works, this painting underwent many transitions. First conceived in 1971 with another model, a family friend, Rosemary Ford, posed in front of a glass door, the artist's initial concern was, as it had been earlier in *Night Window* with reflection. But turning to old drawings of Donna, Pratt's concept changed. Integrating one of these drawings into his composition, he focussed upon those ideas that had previously engaged him in his architectural work — "ideas of inside and outside; belonging and not belonging".[20] Pratt painted Donna as a shadowy figure reflected in the doorway to his living room and, for the first time, the figure was removed from the mythologized archetype of earlier paintings. His painting was about Donna, the person, as no previous work had been.

The final composition does not work exactly as Pratt had intended it to, and Donna appears to stand in an undefined and ultimately impossible space. But if such an effect was not the artist's original intention, it was necessitated by the demands of the painting itself; and the painting is stronger for the ambiguity of her position and the manifold interpretations it suggests. Like the work of the surrealists, of Magritte in particular, the lack of resolution in such a painting adds a tension that heightens its power. If the shadow figure of Donna, locked between wall and door, remains fixed in our minds it is because she has remained to haunt the artist as well.

In 1978, Pratt created his first and only lithograph, *Fisher's Maid* — commissioned by the Canada Council for St. Michael's Printshop.[21] Atypical of his *oeuvre* not only in medium, it is the single mature work in which his wife, Mary, is the principal model and the only print to have a figure as its subject.[22] There is a new richness in the intense blacks, and the print exhibits a sensibility that is foreign to most of Pratt's drawing. Its source was most definitely Edward Hopper's etching, *Evening Wind* (1921), with its rich texture and evocative subject matter.[23]

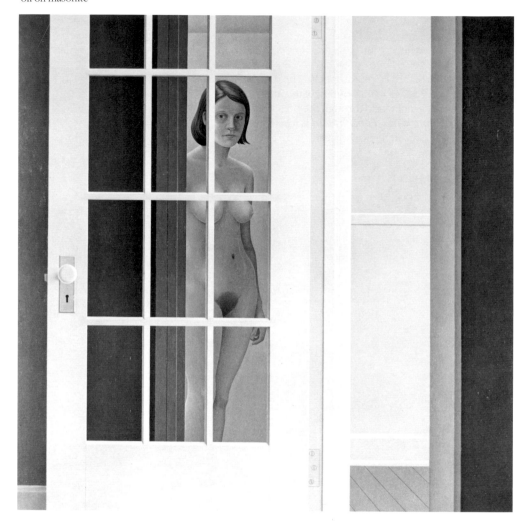

French Door, 1973
oil on masonite

In Hopper's etching the activity takes place in an intimate setting. The girl stretches across the bedclothes towards the open window. Interior and exterior, the animate and the inanimate are linked by the breeze that enters through the window and stirs the filmy curtains. The wind or breeze has been equated with the spirit of life or with divine breath by philosophers. The power of Hopper's work resides in this joining of the internal figure with the external world through the breath of nature. Like *Evening Wind*, *Fisher's Maid* is located in a room with a window, and Pratt also begins with the idea of linking the model directly to the external world.[24] A seascape, originally viewed through the window reflects her attributes, her connections with the world outside and the metaphysical reality that locates her within a timeless space. But Pratt has made the image his own. Unlike Hopper's work, in which the viewer catches the figure unaware, Pratt's model confronts the spectator directly in the early studies. Then in subsequent stages, Pratt shied from direct contact between model and viewer and between interior and exterior space: the model's head is cut off and the window is darkened.

Fisher's Maid, 1978
lithograph

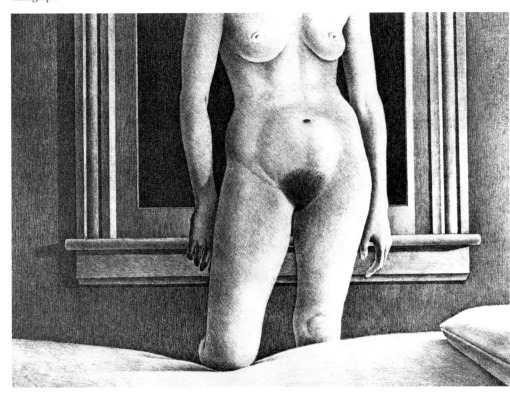

Study for *French Door*, 1973
graphite on paper

Study for *Fisher's Maid*, 1978
graphite on paper

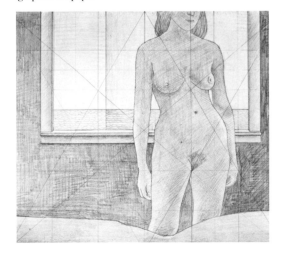

Edward Hopper, *The Evening Wind*, 1921
Courtesy: The Museum of Modern Art, New York

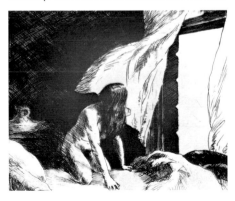

The evolution of this work mirrors Pratt's ongoing preoccupations. His frontal figure is located within the confines of an equilateral triangle that lends a monumental dimension. Details are eliminated, precluding anecdote. At first the window behind opens onto a night seascape; then it is closed. The external world is cut off and so is the dialectic between inside and out. But the vitality and the sensuality that infuse Hopper's nude remains in Pratt's handling of the figure.

Between 1977 and 1980, Pratt struggled directly for the first time with the artist/model subject. In the five panel painting *Me and Bride*, he incorporates his own image, which is present in all his other work only as an unseen force. Implied psychic and sexual tension vie with the sense of estrangement that dominates the space between the artist and his model. This scene began as an interior painting depicting the model looking at her own reflection in the studio window. Then, concerned with the idea of inside/outside, Pratt situated it on a porch.[25] In the end, the space is ambiguous and the absence of reference points forces us to question the painting's meaning. The security of the geometrically constructed architectural space is negated by the boundless external world that invades its carefully constructed barriers. Instead of the intimate and protected interior space of *Fisher's Maid*, the scene is permeated by the vastness of night and the void. To achieve the rich *foncé* of the dark grey-blue ground that activates the surface of the board, Pratt fixed each of the panels to the wall and, mixing the lightest and darkest of the background colours of alizarine crimson and viridian and thirty shades between, moved across the panels to create a sense of unity in the almost imperceptible tonal gradations.

Structurally the painting echoes the proportional concerns and mathematical ordering of Pratt's architectural imagery. But the ordering also establishes rhythm in the space that separates the figures and emphasizes the hiatus that exists between them. Originally *Me and Bride* was only four panels in width. The fifth was added during the creation of the painting to create a complex system of relationships. Measured from the centre of the frame each of the panels has a two to one proportion: the overall proportions are 1:2.5. The entire painting works as a powerful unity; its internal structure is based on an armature of the large rectangle and its major intersections with the armatures of smaller internal rectangles and those of the four overlapping squares. A projection of the diagonal of a drawing board intersects the "balance" line of the figure of Bride at the top edge of the panel in

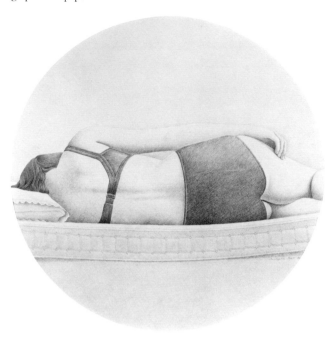

Woman in Black, 1971
graphite on paper

Girl with Small Breasts, 1974
graphite on paper

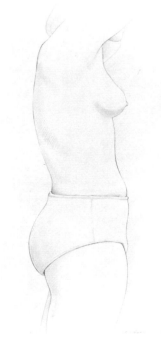

Me and Bride, 1977-80
oil on masonite

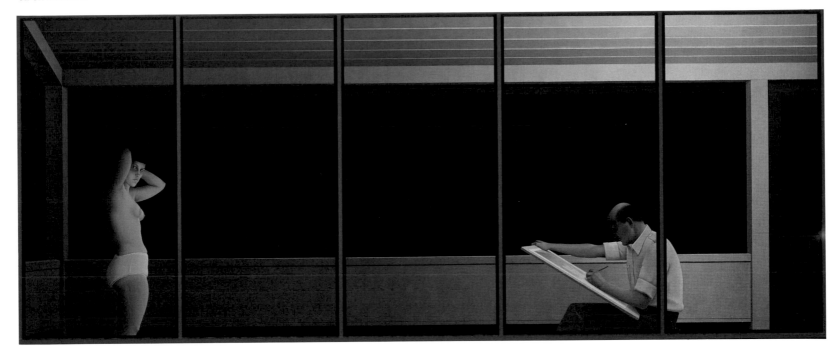

which she is located. Though it is likely that its dimensions were arrived at intuitively, the dark rectangle behind Bride is a golden section rectangle. It is interesting to compare the loose and casual line of the 1975 drawing, *Nude with Raised Arms*, to the figure of Bride. Locked into the geometric structure of the painting through placement and handling, Bride becomes part of an abstracted icon that speaks of the dialectic of inside and outside and of eros and thanatos.

Me and Bride is anti-realistic and generalized. Abstracted sky and water suggest infinite time and space. The dynamic proportions of the composition impregnate the very structure of the painting with meaning. Through subtle control of light and the harmony of the system of proportions, Pratt again forces the medium of paint and the structure of his composition to his will. But the work asserts Plato's contention that the chaos that surrounds us belies the internal order underlying reality.

Pratt has described his first figure paintings as "gener-
alities" informed and influenced by his life experience —
"a collective experience, not a record."[26] The last of
these, *Young Woman in a Slip*, was painted in 1967. The
preparatory drawing for the painting had been evolving
for several years and the pencil study for the figure
involved weeks of work with the model in the studio.
In 1967 Bernadette left and Pratt was without a regular
model. Although he continued to draw from the model
between 1967 and 1973, there were no figure paintings
from these years. Drawings like *Woman in Black* (1971)
and *Girl Sitting* (1972), worked and reworked like the
earlier paintings, came from the same pool of images that
had informed the paintings. Like the idealized 1970
Standing Nude, these drawings were premised upon the
classical contours of Ingres' and the sensuous elegance of
Modigliani's nude studies.[27]

J.A.D. Ingres, Study for *The Golden Age*, c. 1842
Courtesy: Fogg Art Museum, Chicago

Amedeo Modigliani, *Seated Nude*, c. 1928
Courtesy: The Museum of Modern Art, New York

Girl Sitting, 1972
graphite on paper

Nude with Raised Arms, 1975
graphite on paper

Standing Nude, 1970
graphite on paper

It was not until the 1973 painting, *French Door*, that any real change occurred. For the first time the image came from the artist's observations of a particular person rather than an archetypal generalization.[28] A number of things occurred during this period to change Pratt's understanding of the artist-model relationship. Principal among them was the fact that people whom he respected had begun to talk about the female nude in art in terms of the "use" and "exploitation" of women. For Pratt, his earlier work had been a celebration rather than an exploitation but he was challenged to rationalize his work and to defend it. At the same time, he felt obliged to deal with the accusations that his painted figures were "lifeless" mannequins.

In the mid '70s, in works like *Nude with Raised Arms* (1975), Pratt experimented with a looser, less controlled drawing style in an attempt to break with the classical tradition and to imbue his models with a new vitality. Then, after what amounted to a hiatus in figure drawing between 1976 and 1978, he adopted a new approach to the model in the studio, turning from the model as muse to the erotic/personal struggle. In his studio today hang reproductions from Picasso's artist/model series. One portrays the model as inspirational muse.[29] The other portrays the artist as an old and impotent monkey; his model, a vital and assured young woman.[30] Pratt has puzzled over the years about the significance of the artist/model relationship and particularly about the power struggle it implies. In drawings like *Madonna* (1981), and *Girl Sitting on a Box* (1981), Pratt is convinced that it is the model who is in control and he presents her confrontationally, staring at the spectator/artist, demanding attention. In these drawings, the idealized line and non-confrontational pose in works like *Girl Standing* (1970), *Girl Sitting* (1972), and *Summer Place* (1975), give way to direct allusion to a mature sexuality. More explicit, these works are ironically less sensuous.

Model on a Mattress, 1983
oil on masonite (destroyed)

Madonna, 1981
graphite on paper

Summer Place, 1975-78
oil on masonite

Girl Sitting on a Box, 1981
graphite on paper

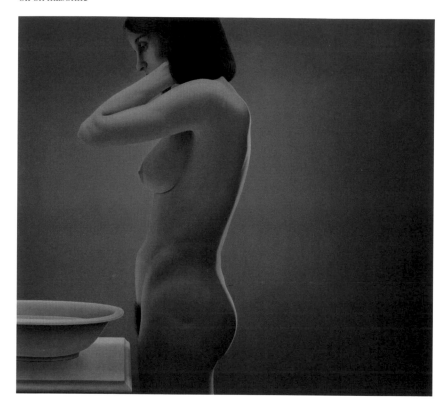

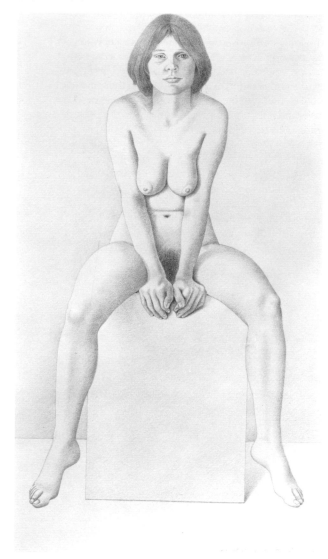

Since 1980, Pratt has again had women posing for him regularly. In 1983, he did a number of large drawings directly onto primed masonite. Subsequently, he worked these drawings into paintings. In these works, memory is no longer employed as a distancing device. Pratt abandons the abstract architectonic order of created environments that had previously absorbed his figures into the composition as a whole.[31] When there are additional elements in the composition, a mattress or a washstand, they are simply appendages to the central figure. Only in *Girl in a Spare Room* (1983), do we sense the possibility of a larger statement. Here, the old issues are alluded to and, through the play of light and equivalences of handling between fleshtones and background, figure and environment become part of a larger statement. But in the other works (two of which the artist has since destroyed), the search for pure form is abandoned in favour of directness. Timelessness accedes to immediacy. In the past, the figure had been part of a larger concept; now the model, herself, is the subject. Seeking a more direct acknowledgment of the model's persona and sexuality, Pratt struggles to be honest to his subject. Unlike Balthus, whose work has fascinated him over the years, Pratt is intellectually incapable of acquiescing to the emblematic, dreamlike and ultimately unreal context in which Balthus locates his figures. Pratt's models refuse to become objects of male fantasy and instead, engage directly in confrontation, excluding the possibility of voyeurism and making the spectator party to the ongoing struggle between artist and model.

NOTES: PAGE 84

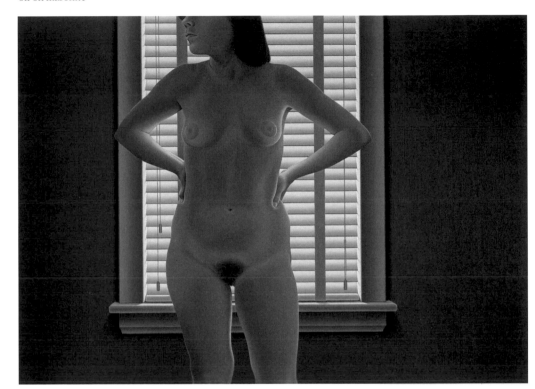

Girl in Spare Room, 1984
oil on masonite

Boat in Sand, 1961
silkscreen

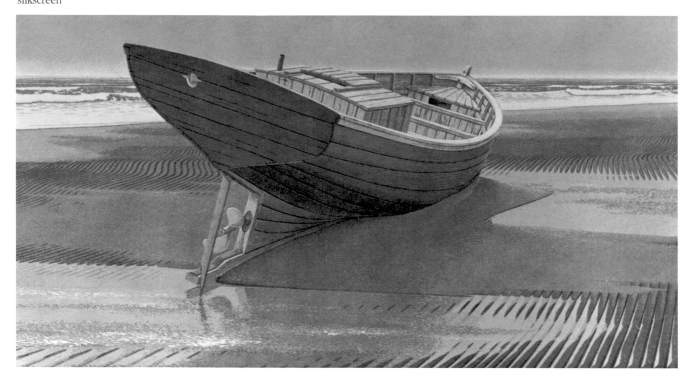

"a taut hollow box, closed against everything external to itself"
Vincent Scully[1]

"every chalice is a dwelling place"
Jean Laroche[2]

Christopher Pratt's earliest childhood memory of a ship was not of any particular craft he had seen but of a *vessel*. It is strange how the mind works. The *Random House Dictionary* defines a vessel as 1) a craft for travelling on water, now usually one larger than an ordinary rowboat such as a ship or boat 2) a hollow or concave utensil, such as a cup, bowl, pitcher vase or the like used for holding liquids or other contents. As examples, it offers these metaphoric definitions: "a vessel of grace, a vessel of wrath."[3] Northrop Frye offers an explanation for this homonymous confusion. Although the Hebrew terms for Noah's ark and the ark of the covenant (the container of God's most precious gift, his covenant with Moses) are entirely different, in the Greek Septuagint and in the Latin Vulgate they are the same.[4] In the daily life of Newfoundland in the forties, ships of every kind were referred to as vessels in common parlance. Daily radio broadcasts announced, as they still do, the arrivals and departures of these "vessels" so that those in outport communities would know when to expect supplies or loved ones. The small child listening to the news, and familiar with the vessel as container, must have imagined those craft less as transport ships than as hollow objects offering protection and safe passage to cargo and passengers.

Later, as a youngster, Pratt would become aware of the stories of adventure and the excitement that coastal communities associated with the sea. He grew up with "stories about ships and schooners, the sealers, whalers, the Portuguese white fleet, destroyers in the war." He remembers the wartime congestion in St. John's harbour and the departures of the North Atlantic convoys. He recalls:

"Our heroes were sea captains. And I always had this notion that the great thing to do was to go to sea. I heard stories of boys who, at the age of sixteen, captained their father's boat to the Labrador, or took a schooner across the Atlantic, or were in charge of fourteen men, and so on. Tales of bravery and heroism at sea. That was the mark of a man."[5]

Pratt's first paintings of boats incorporated this east-coast mythology of valour. His boats sliced through the calm sea or battled valiantly with the rugged ocean swells.

When Pratt first considered painting as a career, he had had no formal instruction. But both his grandfather and Harold Goodrich, a local artist trained in the British watercolour tradition, offered examples of what paintings, and particularly seascapes, should look like. Later Adolf Dehn and Norman Kent offered him Winslow

Homer and Lassell Ripley as examples of artists who treated seafaring themes. In the *Metropolitan Miniatures* a whole volume was devoted to the watercolours of Winslow Homer. In New York in 1956, he sought out *The Gulf Stream*. Pratt's scrapbook of reproductions, clipped from American magazines and the Sunday illustrated papers, contained Homer's *Eight Bells* and *Left and Right*, Albert Pinkham Ryder's *Toilers of the Sea* and a Thomas Eakins boating picture.[6] The American artist and illustrator, Rockwell Kent, rumoured by locals to have been a German spy, was something of a legend in Pratt's childhood and Kent's scenes of Newfoundland and Monhegan Island, Maine, made him an artist of certain influence.

During the first five years of his career, Pratt painted hundreds of boats. In 1956, he painted the *Hemmer Jane*, his Uncle Chester Dawe's large and powerful cruiser, which would provide so many important memories of travelling down the Labrador Coast. Some patrons commissioned paintings of their favourite boat such as *Gypsy in the Narrows*. Others purchased watercolours that derived directly from Homer. In Glasgow, he earned his reputation as an "American painter," for works like the perspective assignment depicting sailboats tacking towards the horizon.

Until 1959, Pratt's boats shared the mythology indigenous to all coast dwellers, that those who live by the sea must be sailors. He came by this heritage honestly. His great-great grandfather, Captain William Knight, had been the sea captain who guided the American painter, Frederick Church, on his 1858 expedition to Newfoundland and Labrador. On his mother's side were generations of owners and masters of vessels. Pratt's early marine images became part of the tradition that had dominated Eastern seaboard painting for almost two hundred years.[7] His paintings affirmed man in his struggle against the sea as did his Uncle's poetry — "uniting the real man with the real nature . . ."[8]

After 1959, his perception of the boat as an artistic subject changed dramatically. Narrative tales of life at sea were rejected and Pratt abandoned the mythology of seafaring in which nautical morality makes the captain "sole master on board."

In Sackville, away from Newfoundland and the sea, the vessel as container began to occupy Pratt's consciousness. There, Pratt created *Boat in Sand*. "The print was like making a window in which I could see a place I wanted to be. I missed the cold, the wet, the smell and the water. As a sailor I have a feeling for the boat in the water, a verb. As a painter I have a feeling for the boat as an object, a noun."[9] Like the "bleached whiteness" of the scapula and the trees, "white as lamb's bones," mentioned in Christopher Pratt's poetry, the beached ribbed vessel may be a conventional *vanitas* motif, attesting to the triumph of death.[10] In the context of Pratt's fixation with the longevity of geological matter and the brevity of biological organic life, the exoskeleton of Pratt's boats merges with the white bones interspersed throughout his poetry; like them they endure. In the decision to beach his craft, Pratt consciously excluded the possibility offered by the skiff in Winslow Homer's *Gulf Stream* — the epic narrative of man in mortal combat with the sea.

In his poem, *1950, Newfoundland*, Pratt alludes to the historical and metaphoric sources of his later boat images:

The boats are all hard up and dry
Drum dry
Echo empty in
The seams all open sun —
High up on the
That's for sure
The fishery
Will never be
No never was
A fit life for a man

Boat in Sand, printed about the same time that Pratt was painting *Euclid Working*, incorporates Pratt's new aesthetic concerns. This is a mental image of a boat; the compositional structure reinforces the total concept.[11] Pratt is no longer concerned with description; it is the boat as shell and as cradle that becomes his subject.

In Roland Barthes' exploration of closure and compatibility, he equates boats to the tents and forts of children, closed off to create a protected safe dream world. Pratt's ship is a box, a habitat, an object that is owned rather than a "travelling eye which come close to the infinite and constantly begets departures".[12] Jung saw the boat as the womb, the first safe resting place.

The silkscreen technique's demands for a precise and linear working method and careful control in registration enhance the focussed and precise method of working that Pratt's new aesthetic concerns required. This need for perfect craftsmanship and painstaking detail became of paramount importance in his new work. Twelve to fourteen screens demanded perfect control and presented the constant danger of overloading the image with pigment and destroying the transparent quality achieved from so many independent layers of paint.[13]

Pratt may have begun with sketches from memory of the skiffs or dories that were found throughout the Avalon Peninsula, but the final image is neither descriptive nor symbolic, anecdotal nor metaphoric. Following the formal demands of his working process and the mental concept that governed the work, Pratt has created an equivalent of experience. Structurally complete the proportions and relations of *Boat in Sand* are mathematically determined. Land, sea and sky are unified through colour and light; the reflective pool in the foreground links the cosmic elements. The boat has been stripped to its essential forms. The last colour laid on was the local colour of the boat, green in response to the muted hues of sand and sea. Like the repeated horizontals of the boards of the boat, the ripples of the sand in the mid- and foreground unify the composition. (The linear elements of the boat relate not to perceived reality but to the mathematical demands of the composition.) Still tied to perspectival rendering of space and a relatively faithful rendering of the boat, Pratt has lifted the image out of ordinary time, confronting us less with factual reality than with recreated reality: this is a print about a boat.

This edition of twenty-five prints brought Pratt immediate attention. His teacher and mentor, Lawren Harris, was one of the first to purchase a print. When Russell Harper visited Mount Allison, he suggested that Pratt submit *Boat in Sand* to the Fourth Biennial Exhibition of Canadian Art in 1961. Selected by the jury, it was later purchased by The National Gallery of Canada for its permanent collection.

New Boat, 1975
silkscreen

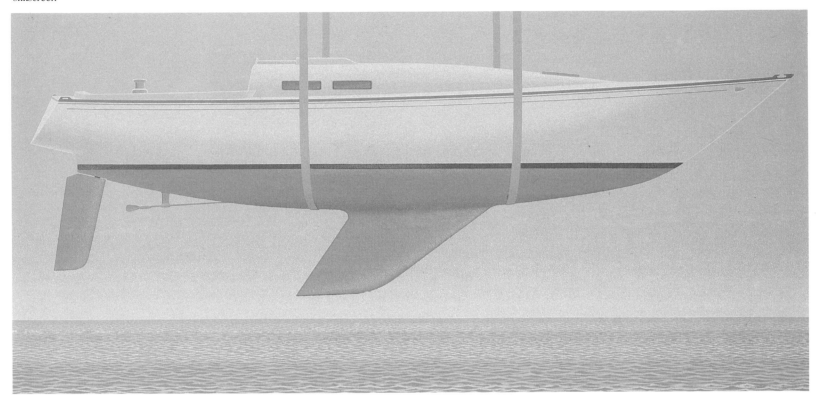

It was not until 1975 that Pratt again worked with the boat image. The serigraph, *New Boat*, depicts a yacht suspended above the horizon line. Truly a twentieth-century icon, this image combines the beauty of functionalism with classical order. His Precisionist predecessors, Charles Demuth in his 1922 *Paquebot Paris* and Charles Sheeler in the *Upper Deck* (1927), had expressed their engagement with the technological age in images of the ocean liner. For Pratt, no battle with a raging sea can show man's conquest of the elements as well as a composition in which ship and sea are portrayed as equals. If *Boat in Sand* was conceived as the legacy of an obsolete life style, *New Boat* is about the future and the capability of modern technology.[14] The unblemished white and blue of the vessel's hull echo the cosmic seascape, geometrically ordered, cool and pristine. The boat is immobilized in space, suspended between the upper limit of the frame and the horizon line. Real time and real place have no relevance in this work.

Pondering images of "inhabiting", Bachelard examines the psychology of interior space and the power of external beauty to obfuscate that central function. He concludes that we may run the risk of concentrating so much on the external beauty of an object that we justify its absolute value by the beauty and solidity of its form while remaining unconcerned with its primary function, which is to protect. A dwelling may be so deeply beautiful that it would be a sacrilege even to dream of living in it.[15]

The tension evident in *New Boat* results not only from its unnatural suspension above the water but also from the unresolved dichotomy between its internal and external aspects. Intrigued with the concept of the boat as a "taut hollow box", the artist's refuge from and shelter in the cosmos, Pratt is also fascinated with its external grace and elegance, with the perfection of its design and by the idea of possessing such an object. Though he creates a ship in which one can confront the cosmos, that ship will not set sail.

In 1975 Pratt completed not only *New Boat* but two other prints, both associated with the sea, *Cape St. Mary's* and *Ocean Racer*. This last work belongs to a century-old tradition of sailing images. Since the development of the camera and the precedent set by Manet's *Boating at Argenteuil* (1874), artists have focussed upon close-up images of sails and sailboats to portray the pleasure of this pastime.[16] In America, Charles Sheeler in his 1922 *Pertaining to Yachts and Yachting* and Charles Demuth in his 1919 *Sailboats (The Love Letter)*, used the beauty of sails for abstracted Precisionist images.[17] Lawren P. Harris, no doubt influenced by the Precisionists, also turned his hand to this subject in *Sails* (1952).[18] Christopher Pratt remembers Mary and several of her friends in Ted Pulford's class in the Owens Art Gallery applying the golden section to an abstracted composition based on a sailboat motif.[19] A year after Pratt printed *Ocean Racer*, Colville would tackle the subject in his powerful image, *Laser* (1976).[20]

A comparison of Colville's painting and Pratt's print exemplifies the important differences between their works. Each shows a sailboat parallel to the picture plane, presumably cutting through the water; Pratt, however, has moved closer into the subject, focussing on the sails.[21] In Colville's painting, a figure hikes over the water, away from us, face partly concealed by the boom and sail. The plastic peek hole reveals an abstract patch of white cloud in a pale blue sky that contrasts with the darker water and the canvas sail. A splash of water in the lower right foreground and the taut sails suggest the boat's speed.

In Pratt's *Ocean Racer*, we see only the configuration of sails, mast, boom, horizon, sky and sea. There is no figure and though the shrouds are taut and the sails raised, there is no other indication that the boat is moving. Parallel to the verticals of the picture frame, the mast anchors the boat firmly and the boom, parallel to the horizon line and to the picture plane, accentuates this steadfastness. Horizontals and verticals are locked in an arrangement as rigid as Mondrian's neo-plastic compositions. Though the Precisionists also focussed on the abstract patterns of the sails, their introduction of futurist force lines suggested the element of time almost as clearly as the transparent splash of water in Colville's painting. Working from abstracted collages rather than from a photograph or a drawing based on life, Pratt finds in the relationships of angles, planes, and colours, a design that captures not a fleeting moment but his experience of sailing. He comprehends the special power of every line and the importance of its placement in the composition. And like Georgia O'Keeffe, he understands the artist's task "to fill a space beautifully."[22]

Alex Colville, *Laser*, 1976
Courtesy: Mira Godard Gallery, Toronto

Charles Sheeler, *Pertaining to Yachts and Yachting*, 1922
Courtesy: Philadelphia Museum of Art

Lawren P. Harris, *Sails*, 1953
Courtesy: Lawren P. Harris

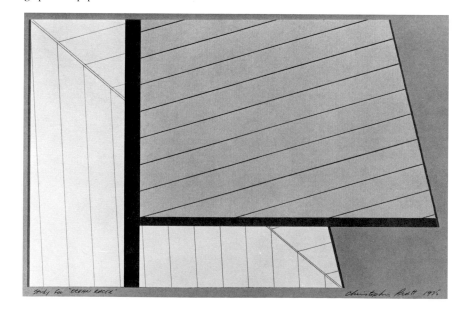

Study for *Ocean Racer*, 1975
graphite on paper

Ocean Racer, 1975
silkscreen

Study for *Ocean Racer*, 1975
collage

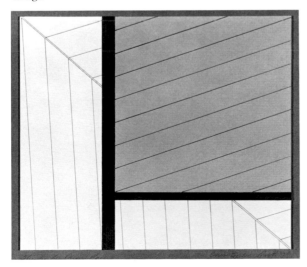

The preparatory collages for *Ocean Racer* are conceptual and abstract: they are about the underlying order that Pratt sees in all of nature. It is certainly more than coincidence that in 1972, he and Yves Gaucher exhibited their prints together.[23] It was in that year that Pratt created the abstract collages associated with the *Strait of Belle Isle* serigraphs, and, for the first time, worked totally abstractly. In the three *Ocean Racer* collages, the structural elements of the subject and the geometric abstraction of the composition are fused. Independent of any external referencing, the collage's impact relies on colour relationships and the felicitous arrangement of the elements.

In the serigraph itself we see the importance of synecdoche for Pratt. The sails represent Pratt's experience of the sea in the same way that the abbreviated, yet infinite wall of *March Night* represents his identification with the dominant clapboard of east coast architecture and with the concept of the protected space. Although the lessons he learned from the collages expedited future simplification and abstraction, Pratt could not make a complete break with visually perceived reality in the serigraph itself.

Though there were passing references to boats in Pratt's work during 1975-1985 and many works actually originated from ideas conceived while sailing, there is only one work that reflects the same concern for boats as "vessels" that we have observed in *Boat in Sand* and *New Boat*.[24] *Yacht Wintering* may, in fact, be seen as a pendant piece for *New Boat*.[25] While *New Boat* is pure in hope and promise, the shrouded form of *Yacht Wintering*, with its dark tonalities and effulgent sunset, has overtones of death and of eternal stasis. Light is a crucial aspect of the composition. Carefully blending the radiant sunset from light to dark through almost imperceptible tonal modulations, Pratt has achieved a luminosity that no solid colour could offer. Like the light of his luminist predecessors, Pratt's winter sunset glows not only with physical but with spiritual power in a frozen immobilized world.

Yacht Wintering, like *Cottage*, recalls a familiar sight, out of its ordinary setting, at rest and unused. Immobilized in its cradle, protected by a dark tarpaulin, the boat is under wraps; a few snow-like shapes suggest winter, Pratt's least-favourite time of year. Like Pratt's earlier boats this ship is a "vessel" but the container protects its inhabitant less in life than in death. It was Mary who pointed out, after the work was completed, that the carefully adjusted intervals of the straps that hold the tarpaulin over the deck and topsides of the boat suggest a body laid out beneath a burial shroud, and Pratt has come to see it as such.[26]

In *Yacht Wintering*, Pratt has unconsciously acknowledged the ritual and symbolic nature of the ship as funeral vessel. An ardent historian of his region and of its Viking heritage, Pratt's unconscious association of the landbound ship and death may have originated in the Viking custom in which ships, separated from their usual environment, became ritual repositories for the dead. The print is as much about death and about unrealized ends as it is about our common assumptions concerning boats and, although he had not originally intended to load it with such a heavy and funereal pessimism, "once work on the print had begun [he] could not have stopped it at any point." Like Marsden Hartley's *Cleophas and His Own* and his *Fisherman's Last Supper*, this too is about the Eastern seaboard, about death associated with ships and the sea, and about burials far from home.[27]

Many viewers have asked, and not entirely facetiously, when Christopher Pratt will get his boats into the water. It may be that he never will. Removed from their usual context, outside of particular place and time, Pratt's boats are existential icons about the nature of contemporary life.

NOTES: PAGE 85

Yacht Wintering, 1984
silkscreen

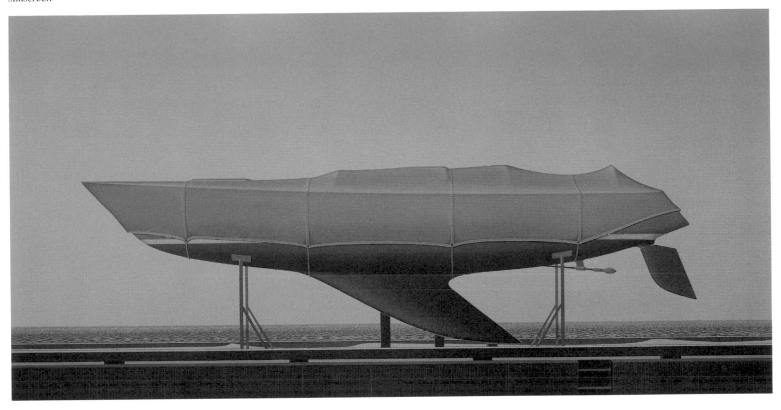

Two Trucks Passing, 1965
graphite on paper

And let them have the sea
Who want eternity

Marsden Hartley

Two Houses in the Spring, 1968
silkscreen

"I see the universe as being a geo-physical entity in which the biological is rare, perhaps to the point of accidental. Water and ice and sky are geophysical elements which attract me for that reason. And when I look over the Atlantic, I can see as much space, and in some ways as much time, as I can see from anywhere on earth, presumably. Even when I look over my shoulder at the land, which is covered with organic matter, I see vast stretches of barren land where nobody lives. I can see huge geographies. This has left me with a sense of openness that I just can't avoid."

Christopher Pratt[1]

"Tell me what your infinite is and I'll know the meaning of your universe: is it the infinite of the sea or the sky, is it the infinite of the earth's depths or of the pyre."

Gaston Bachelard[2]

Christopher Pratt's earliest paintings were seascapes rooted in Newfoundland's traditional love-hate relationship with the sea. Though his 1954 prize-winning *The Bait Rocks*, its storm lashed coast and windblown tree clinging precariously to the rocky shore shares with the Group of Seven the artist's fascination with the elemental power of nature, Pratt painted no densely forested wilderness scenes like Tom Thomson's *Northern River* or Lawren Harris' *Beaver Swamp*. (His little scrub spruce seems dwarfed when compared to Thomson's majestic pine in *The West Wind*.) Despite apparent affinity in subject and style, it cannot be assumed that this painting owed any debt to Canada's Group of Seven.

Newfoundland became a province of Canada in 1949, but its artistic and cultural ties remained north-south. In the mid-fifties, Pratt was more familiar with the work of American east-coast artists like Winslow Homer and Rockwell Kent than he was with that of Arthur Lismer or Frederick Varley. Paintings of Gloucester and Monhegan Island were of more immediate relevance than those of northern Ontario lakes.

At Mount Allison in 1959, Pratt discovered a new source of inspiration. The low, rolling landscape of Sackville and,

even more, his memory of the vast empty stretches that Newfoundlanders call the barrens revealed that the true power of landscape lay, not in descriptive details such as trees and vegetation, but in the geophysical nature of the terrain. Moved by the experience of such spaces and subjects that lent themselves to an abstract interpretation, Pratt began to make drawings of open fields and roads cutting through low-lying plains.

On his return to Newfoundland, the landscape provided Pratt with ideas for drawings such as *Two Trucks Passing* and the print *Plough in a Storm*. Working drawings, dating back twenty years, still offer ideas for landscape paintings. Even today, Pratt cherishes the drive between St. John's and his home in St. Mary's Bay. He never tires of the endless landscape with its peat bogs, windblown and stunted larches, and the occasional peak that gives context to the low undulating terrain. Most of all, it is the light across the open fields that draws him to the road.[3] The vastness of sea, sky and plain constitutes the timeless, measureless infinite upon which he dreams and which has become an increasingly essential focus of his art.[4]

The landscape with its shifting light is a crucial element in the construction of the 1962 *House and Barn* and Pratt extended his investigation of this subject in two prints, *Two Houses in the Spring* (1965), and *Clothesline* (1965). In the first two works, light becomes a metaphor for the wind, the vital life force.[5] In *Clothesline*, Pratt explores another dimension of the notion of place and of belonging. In Glasgow, he had made a few sketches of a woman hanging out laundry in an urban setting. In Sackville, he had again worked with a figure amongst the linens. In the 1965 image, Pratt eliminated the figure. None was necessary. The clothes themselves represent the human presence in a domesticated landscape. Is it only coincidence that the rhythmic undulation of the abstracted white shapes against the Cape Shore landscape seems to echo that of the children who, arms linked, run across the field in Winslow Homer's rural idyll, *Snap the Whip?*

Though Pratt has seldom worked with bird and animal images, he has, on several occasions, introduced creatures that have particular meaning for him in relation to the land.[6] The single animal in *The Sheep* (1971), situated regally in the landscape, is all the sheep that dot the Newfoundland countryside. They are as familiar as fishing sheds and clapboard houses. Preliminary studies for this work included casual drawings of several animals at home in the landscape. But in the end, the casual and the naturalistic give way in favour of the classic. In the superbly controlled final print, however, the artist has added so much detail to the treatment of the animal that the sheep seems almost too real to assume the mythic function which composition assigns it.

In the serigraph, *The Lynx* (1965) the tension is eliminated. This is neither the creature whom Pratt met one day in the woods nor the caged animal that he studied when he determined to depict a lynx. This is Pratt's alter-ego at home, as the artist would like to be, in the countryside. Master of his domain, he strides through the vast snow-covered barrens; only a few bushes and leaves create scale. In this surreal world, light casts no shadow and paws leave no footprints. The animal inhabits the same infinite space which is Pratt's spiritual home.

Clothesline, 1965
silkscreen

Sheep, 1971
silkscreen

The Lynx, 1965
silkscreen

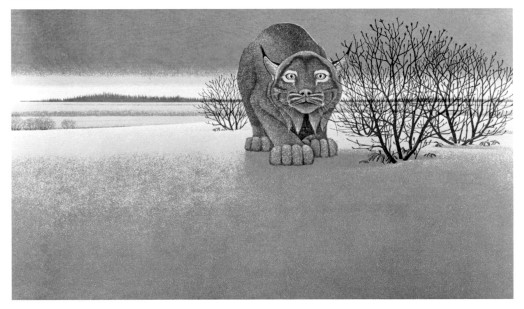

Only when he had established himself at St. Mary's Bay, did Pratt turn again to the sea as a principal concern. But in *Young Girl with Sea Shells*, the artist's mood and intentions changed dramatically from his early work. Here the seas of Pratt's past are stripped of the superficial, the temporal and the conditional. Recognizing that crystalline and geometric perfection surpass descriptive biological fact, Pratt turns to the purity of a conceptual image. Water and sky are measured and disciplined, perfect and iconic.

In childhood, Christopher Pratt believed that the sea "equalled the world" and he dreamed of life as a sea captain; as an adult, he did become a sailor.[7] Although he challenges the sea regularly in his racing, his painting is not about that confrontation. And if his travels from Lake Ontario through the St. Lawrence to Newfoundland have presented sites of interest to him, those geographical sites are transformed into archetypes.

Sea and sky represent the cosmos, and it is in the imagery of infinite space that the artist perceives meaning in the world. Says Bachelard, "Possibly more than any other element, water is the complete poetic reality through which we enjoy, among other things, an intimate taste of our destiny."[8] If Pratt's early storm-tossed seas arose from the culturally acquired local myths of a Newfoundland childhood and a life spent in close proximity to the sea, in his mature paintings the empty sea functions as mediator between land and sky, an intercessor between life and death.[9] In his poetry, Pratt has described the childhood fear of deep water: "fearing not the death that promised life" but "such *non-being* as preceded birth."[10]

Though his happiest childhood memories involve stream fishing and clear hidden lakes, the reflective surface of still water holds no appeal for the mature artist. Instead he consistently chooses the profundity of the sea. Water is the contemplation of the depths of being, of the primitive and the eternal — that prevails over all the time, season and history. Thus, the crests of Pratt's waves are distanced, frozen and abstracted into regularized shapes. The ordinary world of causality is stilled by the geometric ordering of the two dimensional surface. Bachelard suggests that each artist finds a favorite image, a fundamental oneiric temperament. For Pratt that image is architectural but it is seldom separated from sea and sky.

Bay, 1972
oil on masonite

Pratt's most singular and deliberate water painting, *Bay* (1972), is a triptych depicting a flat and light-filled expanse of water. In format, it echoes a medieval altarpiece; in character, it is inspirational. Its central element is a square; its wings are golden section rectangles. The square, combined with either of the side panels, forms yet another golden section rectangle. The horizon line is placed intuitively and, although the whole composition appears to be carefully ordered according to some strict mathematical system, the painting is a response to the internal demands of the composition rather than to any external system of measure.

The idea of sea has been translated into a two-dimensional design. While maintaining strict planar frontality, Pratt suggests spatial recession through the careful manipulation of colour and tone and by gently stepping his horizontal planes back into space. The warm glow of carefully blended light adds a spiritual dimension. Its tonal gradations, imperceptible even on close examination, enhance the timeless surreal quality. John Baur suggests that the luminist painters, Pratt's aesthetic predecessors, achieved a subjectivity so powerful they were able to transfer their feelings directly to the object, with no sense of the artist as intermediary. In *Bay*, Pratt's smooth surface acts as such a "clarifying lens" and we are transported by the luminous immensity of water and sky.[11]

Like Mondrian, Pratt bases his painting on intersecting horizontal and vertical elements, but Pratt has not taken the image of the horizon and the sea to its final reductive geometric purity. For Pratt, the identification with nature and the "thingness" of things remains too strong. Pratt, too, seeks to know the order of the world but, unlike Mondrian, he does not believe it need be stated in non-objective terms, although in this painting, Pratt's unrelenting search for first principles has led him very close to pure abstraction.

Bay grew out of Pratt's preliminary work for the three silkscreens, *Ice* (1972), *Strait of Belle Isle* (1972), and *Labrador Current* (1973). The prints took on a new nature when Pratt began to experiment with collages in which earth, sea, ice, and sky were posited as rectangular elements of coloured paper aligned one on top of the other, parallel to the picture plane.

Ice, 1972
silkscreen

Study for *Labrador Current*, 1973
collage

Labrador Current, 1973
silkscreen

Once again, the artist was drawn to the non-objective and, as he had at Mount Allison, Pratt refused total abstraction: these seascapes are tone poems that evoke the mood of the sea. Their skies are saturated, as moist and opaque as the icy sea below. Their real subject is the melancholy grandeur of the northern ocean's unbounded vistas. Like *Bay*, which was also premised on abstract collage studies, these works derive their strength, in large measure, from the interaction between the powerful appeal of pure abstraction and the poetic reality of the sea.

In 1973, Pratt painted *Cottage*, a work which he describes as being about out-of-season experiences rather than the water itself. Like his architectural works, the image describes the confrontation between boundaried place and unbounded space. Though the empty deck of the cottage and the sea are structurally and tonally unified, the artist introduces several elements that separate foreground from background, shelter from cosmos. First, he locates the vanishing point just below the centre of the doorway instead of on the horizon line which prevents our eye from moving naturally back into the distance.[12] This effect is reinforced by the omission of a central ground which precludes easy transition from inhabited space to the sea beyond. Although preliminary drawings emphasize the underlying pattern of floor boards and ceiling joists that thrust out into the space beyond the architectural environment, the repetitive rectangular panels and screened doorway combine with the tilted perspective to separate the viewer from the sea, forcing us to remain inside looking out. In fact, the sea is not a true extension of our pictorial space.

Western Shore, 1979
silkscreen

Study after *Western Shore*, 1980
graphite on paper

Cottage, 1973
oil on masonite

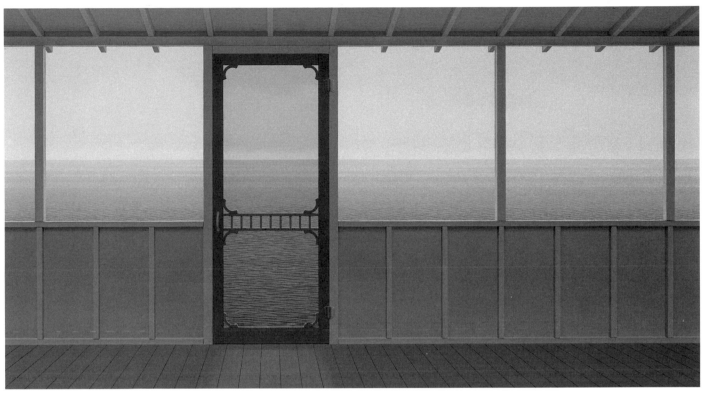

Edward Hopper, *Rooms By the Sea*, 1951
Courtesy: Yale University Art Gallery

Alex Colville, *Verandah*, 1983
Courtesy: Mira Godard Gallery, Toronto

This composition may have been triggered by the latent memory of Edward Hopper's painting, *Rooms By the Sea* (1951), which Pratt had known in reproduction. In each, an interior space abuts a seascape with no middle ground. But in Hopper's painting a wedge of light floods the room in an almost anthropomorphized manner and the brilliant blue of the seascape invades the room. Despite the abrupt transition between architecture and seascape, there is a sense of warmth and belonging, of real space and stopped time. Alex Colville's measured *Verandah* (1978), appears at first to be a populated "Pratt" but it is based on a different premise. In Colville's painting, each figure is absorbed in a leisure activity and the porch is extended to create a space in which people and animals can move about. Though movement is frozen, time might resume at any moment, there is no dislocation between interior and exterior space. Pratt's painting is clearly about other things. Engaged by the infinite expanse of sea and the cool light that irradiates the horizon, we are involved in an act of quiet and melancholic contemplation.

Memorial Window, 1982
silkscreen

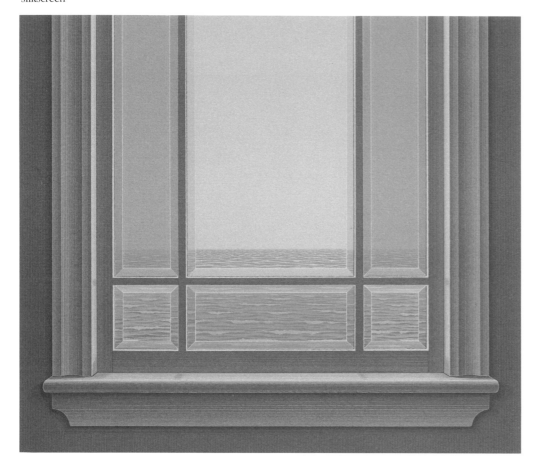

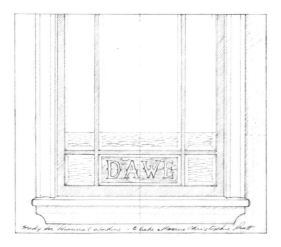

In *Parish Hall*, Pratt views the image of the ocean through a series of regular windows that, like the triptych frame of *Bay*, become iconic. Though Pratt suggests that the parish hall is parochial in its concerns, in this work its function is transfigured. The interior of the hall is painted in the same values as the sea beyond, where the elements of haze, cloud and fog blend to obscure the distant bank of land. The windows intercede between the world of man and the infinite. The repeated architectural elements of *Parish Hall* operate like a screen: we are not intended to occupy the space of the hall, but to address the haunting image of the sea beyond.

Though the sea remains a constant theme in Pratt's art, *Bay* and the *Strait of Belle Isle* prints represent the point at which the sea became both a principal theme and the means by which he contemplated, however briefly, total abstraction. In 1979/1980, three more serigraphs of the sea were created. In *Western Shore*, *Labrador Sea* and *Hawke Bay* there is a sharper focus, more detail and a greater sense of particular atmospheric conditions than in the 1972 seascape prints. *Labrador Sea* appears to capture the curl of waves frozen by the camera's lens. In *Hawke Bay*, a ridge of ice hovers on the horizon. *Western Shore* is dominated by an ephemeral cloud formation. Although the cloud evolved from a simple, lyrical abstracted drawing, the temporal effect of a sky heavy with moisture changes our perception of the cold sea below, and we are tempted to read the scene in terms of real time and place.

In a later print, *Memorial Window* (1982), Pratt once again has created an image that addresses his most pressing aesthetic concerns. Mathematical order, precision of execution, and complicated internal framing devices, incorporated into the structure of the image, create a visual unity. The seven golden section rectangles of the window enclose the same conceptual seascape that has appeared abstracted and locked in rectangles throughout his *oeuvre*. The dynamic relations of its proportions, "as abstract in its way as anything in the work of Mondrian, Newman or Rothko", frame the idea of the sea — the infinite upon which Pratt dreams.[13]

NOTES: PAGE 86

Parish Hall, 1974
oil on masonite

Study for *Whaling Station*, 1983
graphite on paper

Gaston Bachelard proposes that the "true product of the imagination seizes us, holds us and infuses us with its being".[1] *Whaling Station* (1983), is such an image and it seems appropriate to end this text with a discussion of this work which can be seen as a resolution of the concerns that have occupied Pratt for the past twenty-five years. Like all of Pratt's mature work, this painting adheres to the conditions of the American luminist-classic aesthetic. Abstracted and monochromatic, it is dominated by a rigorous horizontal planarism, precise line, smooth surface, a non-specific luminosity and classical silence, making style the "accomplice of concept".

In 1972, boating with family and friends on the Labrador coast, Pratt visited the abandoned Hawke Harbour whaling station. It had been destroyed by fire: twisted pipes, tanks, flues and metal pieces were everywhere overgrown with grass and flowers. But the bunkhouse "a dull, railway-red clapboard building" had survived.[2] In it, Pratt felt the loneliness and the isolation of the whalers' lives in the moldering wooden bunks that lined the walls three deep like shelving. Scratched into the wall, graffiti chronicled the whaler's days: "5 whales today; 37 whales to date; 30 days left to go;" and the inhumanity of life at Hawke Harbour. Everywhere there was the residue of blubber and blood, "slimed" on, spewed from the flensed whales.[3] There was iron too — rusting and wet.

Though the icy reaches of the serigraph, *Hawke Harbour* (1980), eventually evolved from this journey, the whaling station and the bunk house remained to haunt him. The image was noted in a simple line drawing, made on his return, of horizontals and verticals ruled off to represent the bunks. In his original plan, Pratt envisioned a disconnected triptych with the large principal golden section "bunk" panel supported by a supporting narrow panel to represent the graffiti encrusted wall and third panel, a square, to represent the feeling of the place as a whole — a dark landscape or seascape.[4]

Unresolved, the image remained for ten years in Pratt's "to be done" file until 1983, when he determined that the main panel should stand on its own. With no additional preparation, he transferred the 1972 drawing to the prepared masonite surface and began to paint.

To capture the mood of the place — the iron, grease and blood and the melancholy — and to activate the painting's anonymous flat surface, Pratt created a vital grey surface by subtly blending alizarin crimson and viridian. Touches of indian red, earthy and strong, resonate against the bluish cast of the grey to suggest a human presence.

Graffiti at Hawke Harbour, 1972
graphite on paper

There is another souvenir of a whaling experience which stands today in Pratt's studio. It is an explosive harpoon head rescued from William's Port in Newfoundland, rusted brownish-red with a bluish cast. It might be said that *Whaling Station* is as much about living with this ponderous and lethal object as it is about the experience of Hawke Harbour.

The final painting changed little in format from the drawing of ten years earlier. It was one of those instances, more frequent recently, when the concept of a work has come to the artist fully developed. All that was left was to feel his way in response to the paint itself, as the image came to life. Though the starting point was Hawke Harbour, the final painting resonates with a power that subsumes particular place and time. The virtually abstract image possesses its own history, evoking archetypal precedents. In Joseph Conrad's novel, *The Nigger of The "Narcissus"*, the ship, "the Narcissus" carries "shades"; its berths "narrow niches for coffins in a white washed and lighted mortuary".[5] Though Pratt admires Conrad's writing and though his painting evokes a similar mood, the artist relies on neither symbolism nor metaphoric references. Only Pratt's title remains to give us access to the nature of the experience that inspired it. Yet the painting's luminous steel grey surface, stained with red and dominated by the uniform simplicity of the precisely designed bunks, communicates no less directly the sorrow and the overtones of death that permeate Conrad's description. In the end, the painting, rooted in the world of representation, stands independent of personal travails or experiences, surpassing even its specific origins in the directness and the potency of its abstracted image.

To enhance the abstract power of *Whaling Station,* Pratt relied on synecdoche as he had in his major architectural images of the past fifteen years. As in *Station* (1972), *Sunday Afternoon* (1972), *Coley's Point* (1973), *Subdivision* (1973), *Front Room* (1974), *Parish Hall* (1974), *Federal Area* (1975), *March Night* (1976), *The Visitor* (1977) and *Basement Flat* (1978), Pratt employed part of a wall to represent the architectural whole, thus precluding the viewer from reading symbolic intent into the work and, at the same time, ensuring that it cannot be read as direct representation. As Roland Barthes has noted, a complete image would preclude myth.

Whaling Station differs in one fundamental way from the rest of Pratt's work. The wall in this painting no longer performs its primary function, that of separating interior from exterior space. Instead, the internal space of the bunkhouse melds with cosmic darkness.[6] In earlier paintings such as *House and Barn* (1962) and *March Night* (1976), the sheltered world of architecture confronts the external infinitude of the cosmos. In such works the contradiction between place and space, between interior and exterior, speaks not only of physical but of existential belonging and alienation. In earlier images geographic space is divided into house and non-house, and the house, our first universe, embodies a protective refuge for human experience. Suggesting on more than one occasion that architectural images are synonymous with his own presence, Pratt has described his dominant concerns as those of inside/outside, near/far, open/closed and finite/infinite. We might add to that list the most significant of all dyads: life and death — eros and thanatos.

From the box-like dwellings of *House and Barn*, situated in the windswept plains of the Newfoundland winter to the abrupt synecdochic clapboard surface of *March Night*, separated from the infinite cosmos by only a thin edge, Pratt has contemplated the dichotomy between immediate place and the receding continuum of space, a duality that Mircea Eliade and Martin Heidigger (as well as Bachelard) see as central to human experience. In *Whaling Station* the dichotomy is destroyed and Pratt subsumes the bunk house in darkness. Interior place and exterior space are unified in the quiet gloom of eternal night.

In style, method of working and concept, *Whaling Station* is characteristic of Pratt's *oeuvre*. Its image requires no previous knowledge of the experience that brought it into being. That experience, filtered and processed through time and reverie, is only the seed for the work's fruition. And though its source lies in the external world of objects, Pratt's painting is self-contained, ontologically complete. Ideal rather than real, conceptual rather than perceptual, Pratt's image integrates idea and feeling into the very structure of the composition. In experiencing his images, we experience their archetypal power.

NOTES: PAGE 86

Whaling Station, 1983
oil on masonite

1. Gaston Bachelard, *Water and Dreams* (Dallas: The Pegasus Foundation, 1983): 1.

2. Interview with the artist, March 6,1985.

3. Martin Friedman, "The Precisionist View," *Art in America*, Vol. 48, No. 3 (1960): 33-36.

4. Barbara Novak, *American Painting in the Nineteenth Century* (New York: Harper & Row, 1979).

5. David Silcox, *Christopher Pratt* (Scarborough: Prentice-Hall Canada Inc. 1982): 82.

6. Dennis Reid writes "If a continuing tradition does develop in the Atlantic provinces it will perhaps grow around the work of these 'magic realist' painters." Reid, *A Concise History of Canadian Painting*, (Toronto: Oxford University Press, 1973): 267. However comparison of paintings included in exhibitions such as the London Regional Art Gallery's 1966 "Magic Realism in Canada" or the Beaverbrook Gallery's 1974 "Colville, Pratt, Forrestall", and the Centre Canadien Culturel's exhibition of the same year featuring the work of D.P. Brown, Ken Danby, Tom Forrestall and Pratt, indicates that, though it has often been attempted, we cannot easily locate Pratt within this "Mount Allison School of Realism".

7. Michael Greenwood: "Current Representational Art: Christopher Pratt," *Artscanada* Vol. 33, No. 4, Issue No. 210/211, (Dec. 1976, Jan. 1977): 31.

8. Quoted by David Burnett in *Colville* (Toronto: McClelland and Stewart, Ltd. 1983): 204.

1. Northrop Frye, *The Bush Garden* (Toronto: Anansi, 1971): ii.

2. Christopher recalls that as a child he painted watercolour Christmas cards of Newfoundland winter scenes with his mother. Philip Pratt studied at the University of British Columbia. His architectural work, primarily in St. John's has won several awards including a Canadian Housing Design Council award for residential design. He is also a photographer.

3. See The Metropolitan Museum of Art, *Metropolitan Miniatures* (art gallery album). Each volume included a perforated gummed sheet of twenty-four colour illustrations. This series included monographs on a number of artists including Winslow Homer (Volume 88) and Piero della Francesca (Volume 59); masterpieces from American and European collections including The Philadelphia Museum of Art (Volume 32 and Volume 70), the Metropolitan Museum of Art (Volume 33), the Museum of Modern Art (Volume 85) and the National Gallery of Art, Washington, (Volume 45). A number of monographs written by art historians and curators were devoted to the various aspects of American art including *Three American Watercolorists; The American Scene* (Volume 26); *Twentieth Century American Painting* (Volume 17) and *Two Centuries of American Painting* (Volume 24). In 1958 and 1959 the *Metropolitan Seminars in Art* (Portfolios A-L) were also published with texts by John Canaday. Pratt also had access to these.

4. Letter from Lawren P. Harris to Mr. J.K. Pratt, 93 Waterford Bridge Road, St. John's, October 26, 1953. In the artist's possession.

5. *Ibid.*

6. Pratt recalls that his father never replied to the letter, querying whether the sender "had all his marbles." Interview with the artist, May 13, 1985.

7. *Metropolitan Miniatures: Giotto* (The Frescos of the Arena Chapel) Vol. 63.

8. Several of Pratt's poems have been published. (i.e. *Newfoundland Quarterly* 55 (June 1956) "How Soon When the Day is White" and "October is the Ocean's Spring": 45 and "How Soon When the Day is White," in *Atlantic Anthology*, ed. Will R. Bird (Toronto: McClelland and Stewart Ltd., 1959): 160. In addition a number of his works have been set to music by University of Western Ontario Professor of Music, Jack Behrens.

9. Interview with the artist, May 9,1984.

10. H. Ruhemann and E.M. Kemp, *The Artist At Work* (Great Britain: Penguin Books,1951).

11. Adolph Dehn, *Watercolour Painting* (New York and London: Studio Books, 1945). Adolph Dehn (1895-1968), was born in Waterville, Minnesota and trained at the Minneapolis Art Institute. A leftist artist, he was associated with *The Masses* and its successor *The Liberator*. He moved to New York early in his career. Even there his major interest seems to have been identified with rural landscapes in the Burchfield tradition. None of his glowering machine-age monsters are represented in the watercolour instruction book that so influenced Pratt and none of his concerns about social revolution are indicated in the rolling rural landscapes and open seascapes that he chose to illustrate.

12. Norman Kent, *Watercolour Methods* Ed. Ernest Watson and Norman Kent (New York: Watson Guptill, 1945). This text gave specific instructions on technique and the method of constructing a watercolour painting. It was well illustrated and it is clear that Pratt followed Kent's instructions during this period. A number of the illustrated paintings were accompanied by diagrams that described how the painting was constructed, emphasizing the need to keep the image parallel to the surface (see pages 74,75). A. Lassell Ripley's *Freighters* (page 47) was much admired by Pratt and his *View of St. John's Harbour* (1955) 15.3 x 24.2 cm. (in the collection of Christine Pratt), is an interpretation of this work. Pratt took this book to Glasgow with him.

13. Dehn, *Watercolour Painting*: 46.

14. Note to the author, July 6, 1985. In the January 23rd, 1956 issue of *Time* Magazine Vol. 67, No. 4: 38-39, there was a feature article on Charles Burchfield. See also *Arts* (*Artsmagazine*) Vol. 30 No. 4 (January 1956): 26-31, Lavern George, "Charles Burchfield." These articles were written in conjunction with a retrospective exhibition that opened Jan. 11, 1956 at The Whitney Museum. The George article mentioned John Baur's *Charles Burchfield* (MacMillan and Co.), which Pratt subsequently purchased.

15. Pratt dated this work 1952 long after the fact. It seems almost impossible that it should have been done in the first year that he began to paint. If it had been done that early and received such positive response, it is surprising that it was not among those works taken to Mount Allison in Pratt's portfolio in 1953. Today, Pratt acknowledges that the date of 1952 is too early and suggests that it was done in late 1953 or 1954. It seems most certainly to have been done before he left Mount Allison in December, 1955.

16. See the January 3, 1955 issue of *Time* Magazine Vol. 65 No. 1: 54-56. The article featured Charles Sheeler's work in conjunction with his travelling retrospective during 1955. It reproduced *Family Group*, *Rolling Power* and *The Artist Looks at Nature*. Pratt specifically recalls this article. In *Life* Magazine, March 28, 1955, "150 Years of Fine Arts," there was a full colour illustration of Charles Demuth's *My Egypt*: 75.

17. In a note to the author, July 4, 1985, Pratt recalls seeing Lawren P. Harris' gouache of a tank on a flat car (one of his war paintings) probably in the fall of 1953. Another work by Pratt in this style represented "an oil car on a railway track as if it were out on a prairie."

18. Interview with the artist, May 16, 1984. Winslow Homer, *The Gulf Stream* (1899), in the collection of the Metropolitan Museum of Art. This work was reproduced in *Winslow Homer* (Vol. 88) in the *Metropolitan Miniatures* series.

The artist also recalls clipping a reproduction of the work and hanging it on his bulletin board. Homer's seascapes were reproduced in the April 1956 issue of *Arts* (*Artsmagazine*) Vol. 30 No. 7: 37 (*To the Rescue*); in the May 7, 1956 issue of *Time* Magazine Vol. 67 No. 19: 55 (*A Summer Squall*); and in the May 1957 *Arts* (*Artsmagazine*) Vol. 31 No. 8: 12 (*Northeaster*). (These are only a few of the many reproductions of Homer's work that appeared in publications Pratt read regularly during these years.)

19. Edward Hopper, *House by the Railroad* (1925), oil on canvas, 61 x 73.7 cm., in the collection of The Museum of Modern Art, New York. It is interesting to compare later works of Pratt such as *Railway* (1978) with this painting. Hopper's work was reproduced in the May 30, 1955 issue of *Time* Magazine Vol. 65 No. 22: 51 (*Early Sunday Morning* and *Cape Cod Morning*); in the June, 1956 *Arts* (*Artsmagazine*) Vol. 30 No. 9: 26 (*Early Sunday Morning*); and in the Dec. 22, 1956 cover story of *Time* Magazine Vol. 58 No. 26: 30-41 (*Early Sunday Morning*). Pratt would certainly have known Hopper's work from the *Metropolitan Miniatures*.

20. He was familiar with Sheeler's work before this trip. See footnote 16 this chapter.

21. Pratt still owns John Bauer, *Charles Burchfield* (New York: Macmillan 1956) and Lloyd Goodrich, *Winslow Homer* (New York: George Braziller, Inc. 1959).

1. John Betjeman, "Aberdeen Granite" in *First and Last Loves*, (London: John Murray, 1952): 23.

2. Interview with the artist May 6, 1984. In New York in 1956, Pratt visited the Arts Students' League; he found it empty of activity and disappointing. In Toronto on the same trip, he visited The Ontario College of Art.

3. Interview with the artist, March 2, 1985. (He sent them watercolour paintings in a tube.) He had also applied to Liverpool, Cardiff, Sheffield, the Slade, and St. Martin's.

4. Author not noted, *The New Scottish Group: Modern Scottish Painters*, Book I (Scotland: William McClellan 1947): 6.

5. Jessie Alexandra (Alix) Dick (1896-1976) was born in Largs, Ayrshire just 30 minutes from Glasgow and was a painter in watercolour and oils. She attended the Glasgow School of Art from 1914-1919 and was hired in 1921 to teach first year. The winner of the Lauder award in 1953, 1959 and 1965, she became an associate of the Royal Scottish Academy in 1960. Her work was relatively conventional: sensitive portraits, landscapes and still lives and showed an understanding of cubist theory. More often than not, her approach was strongly naturalistic. An article published March 10, 1930 in the *Herald* described *The Nomad* as a "courageous essay in realism, vitally conceived and vigourously painted." Her former colleague, Mary Armour, characterized her classmate as a conscientious, pleasant and a good student who instilled in her own students a love for fine drawing and painting.

6. Interview with the artist May 6, 1984.

7. *Ibid*.

8. Interview with Jack Knox (currently Head of Drawing and Painting at the Glasgow School of Art. He attended the Glasgow School of Art during the same period as Pratt) June 29, 1984.

9. *Glasgow School of Art Prospectus*, 1957-58.

10. Interview with the artist May 16, 1984.

11. When Pratt painted two figures on a headland, Miss Dick argued the need for a more appropriate technique, closer to Boudin or the English watercolour school than to Homer or Wyeth and the American tradition. Pratt however was more vividly aware of the tradition of Homer and Marin that he was of misty views of Salisbury plain. Interview with the artist May 7, 1984.

12. Though he did not travel to the continent, he did purchase on his arrival in Scotland, a complete set of Skira's *Great Centuries of Art*.

1. In the publication *Food For Thought*, Vol.15 No. 4 (January 1955): 13-17, Lawren P. Harris refuted an article by Eric Newton titled "Canadian Art in Perspective" that had appeared in *Canadian Art* Vol. 11 No. 3 (Spring, 1954): 93-95. Newton charged that the Maritimes were "isolated from the main cultural currents of both Europe and the rest of Canada" and that there was a definable Maritime style. Though Harris agreed that Colville's art "almost constitutes a contemporary genre form," the description of his own work (written by L.M. Allison, Librarian at Mount Allison), shows it as having progressed "through the stages of realism and naturalism to abstraction." Discussing Jack Humphrey's recent work, Harris described its abstract expressionist qualities and he linked Ruth Wainwright's work to that of Hans Hofmann in its "strong plastic quality." Harris thus tied the contemporary Maritime scene to the contemporary "universal art movement" that "transcends the narrow regionalism of the past."

2. David Burnett, *Colville* (Toronto: McClelland and Stewart, 1983):113.

3. Interview with artist, May 13, 1984. Pratt had been "transported" by the reproduction of the Fitzgerald work when he first saw it. (A clipping of the work is still in his possession.) Pratt's impression was confirmed when he saw the work exhibited at The National Gallery of Canada several years later.

4. See "Architecture: The Notion of Place," footnote 6, for a discussion of the golden section.

5. The exact source of the golden section in Pratt's work is uncertain though Alex Colville relied strongly on mathematical formulae and on the golden section to construct his images. Christopher remembers Mary working on an assignment based on the golden section rectangle in Ted Pulford's class. Though Pratt never learned this lesson formally, it seems clear that he first came upon the concept of the golden section in discussion with Mary and that Mary became engaged by it in Pulford's class. Her interest in the subject, though it was never applied to her own work, was not new. (Her father, William J. West, himself an amateur painter as well as lawyer, judge and politician, had introduced her to the concept many years earlier.)

6. Jack Humphrey won first prize.

1. Unpublished poem by Christopher Pratt. (Italics the author's.)

2. Adolph Dehn, *Watercolour Painting*, (New York and London: Studio Books, 1945): see especially pages 30-43.

3. This painting was done as an assignment to paint "a view through a window." It is interesting to note that *South Side*, done several years earlier, had established Pratt's interest in the window as a framing device.

4. Born in Glasgow in 1932, Morrison exhibited regularly in Glasgow. He had a one-person show at the McClure Gallery in 1958. Pratt recalls seeing his work in a private collection.

5. E.H. Gombrich, *The Story of Art*, (London: Phaidon Press Ltd., 1950): 183. (Reference in this publication is to the 1971 American edition.) Gombrich was most certainly Pratt's source for the study of this work. He draws attention to its "neat mathematical arrangement." His text was required reading at the Glasgow School of Art.

6. Euclid theorized that a straight line is said to have been cut into an "extreme and mean ratio" when, as the whole line is the greater segment, so is the greater to the less. This "golden section," known to artists and mathematicians since the time of the Greeks and used extensively in the Middle Ages and during the Renaissance, was given the name "Divine Proportion" by Luca Pacioli in the sixteenth century. It was purported to have symbolic and mystical properties. The ratio is $a/b = b/a + b$. Ted Pulford taught the golden section as a means of structuring compositions and Pratt had actually seen such a class exercise as early as 1954 or 1955.

7. Though it wasn't until 1964 that he acquired Charles Bouleau's *The Painter's Secret Geometry* with a preface by Jacques Villon (London: Thames and Hudson, 1963) — a book specifically devoted to the mathematical possibilities of constructing two-dimensional images upon a system of proportions — Pratt was aware of such systems during this Mount Allison period.

8. This subject would be revised during the next several years in *Clothesline* (1965), *Two Houses in the Spring* (1965) and *Barn and Cellar* (1969).

9. French philosopher, Gaston Bachelard, explored the philosophical significance of the kinds of space that attract the poetic imagination. He sought to determine how the poetic image is apprehended, not by psychology or rationalism, but by recourse to phenomenology — the onset of an image in the individual consciousness. I believe that Bachelard's philosophy of the poetic image parallels almost exactly the way in which Pratt's artistic images develop. For that reason, I have drawn on Bachelard's insights throughout this text. Gaston Bachelard, *The Poetics of Space* Maria Julis tr (Boston: Beacon Press, 1969): 3.

10. David Silcox, *Christopher Pratt* (Scarborough: Prentice-Hall Canada Inc., 1982): 49.

11. Vincent Scully, "The Precisionist Strain in American Art," *Art in America*, Vol. 48 No. 3 (Fall 1960): 46-53. Traced from the early limners and John Singleton Copley, this strain has been identified in nineteenth century American art as luminism. In the twentieth century, it integrated Cubism and Purism into a modernist American aesthetic and dominated the work of Precisionist artists like Charles Sheeler and Charles Demuth and poets like William Carlos Williams. In the 1950s and 60s, American art found new vitality in the hard-edge and geometric abstraction of artists like Josef Albers and Sol Lewitt.

12. *Ibid.*: 46-47.

13. *Ibid.*

14. Rudolf Arnheim, *Art and Visual Perception* (Berkeley and Los Angeles: University of California Press, 1969): 51. Arnheim points out that the gestalt psychology has named this correspondence "isomorphism."

15. I am indebted to Daria Darewych for this analysis.

16. See the photo of the interim state which reveals the cellar, and an off-centre chimney. Note the absence of a door.

17. Interview with the artist, August 24,1985.

18. At first a simple cottage, Salmonier would grow incrementally to include not only improved living space for the family, but better and larger studios for both Mary and Christopher.

19. See *Window by the Sea*, *Young Girl with Sea Shells*, *Night Window*, *The Bed*, *Bed and Blind*, *Trunk*, etc.

20. There can be little question that this work was inspired by Odilon Redon's lithograph *The Light of the Day* (1891) reproduced in Paul Sachs, *Modern Prints and Drawings* (New York: Alfred A. Knopf, Inc., 1954): 38. This book, which Mary brought with her to Newfoundland in 1956, was an important resource for Pratt — especially after his move to St. Mary's Bay in 1963.

21. The device of the window is used continuously from this time forward. In *Federal Area*, Pratt uses the device of the window as picture frame — though in this case the metaphor is not entirely successful. In *Cottage*, *Parish Hall*, *Apartment*, *Bed and Blind* and *Trunk*, the view through the window to an infinite space is conceptually stronger. A window frame was originally intended to surround the print, *Western Shore*. We shall examine Pratt's continued exploration of the window motif and its implications further, but it is interesting to note the watercolour, *Window with Lace Curtain* (1964). Like the later *Tessier's Barn*, it is a digression from Pratt's growing resolve to eliminate elements of the picturesque from his work. Here, peeling paint and rotting wood imply duration which would seldom recur in Pratt's work. It is interesting to note the transparent curtains in this work. A device meant to link outside and inside, curtains would be virtually eliminated in later work where the external screen walls would exclude all possibility of access.

22. Bachelard, *The Poetics of Space*: 48.

23. *Ibid.*: 4-6.

24. *Ibid.* See pages 18-20 for a discussion of cellar imagery. Pratt has said: "The back of our flat on Le Marchant Road had a clear view of St. John's Harbour, but the front was underground, funereal. I've had a fascination with, and a horror of that kind of environment ever since." Silcox, *Christopher Pratt*: 177.

25. Whitney Collection: Museum of American Art (oil on wood) 40.7 x 30.2 cm.

26. Northrop Frye, *The Great Code: The Bible and Literature* (Toronto: Academic Press Canada, 1982): 158. Frye goes on to say that Danté connected heaven and hell, earth and purgatory with a staircase; Yeats' use of the metaphor in *The Winding Stairway* provides a more contemporary demonstration of the continuing relevance of the stairway motif in modern literature.

27. Carl Jung, *Modern Man in Search of a Soul* (New York: Harcourt, Brace and World, 1933) quoted in Bachelard, *The Poetics of Space*:18.

28. Bachelard, *The Poetics of Space*: 25-26.

29. *Ibid.*: 25.

30. *Ibid.*:79.

31. *Ibid.*: 9.

32. "Synecdoche," a literary term, has been applied to a technique used by a number of artists, including Edward Hopper. It is the substitution of a part for the whole. This technique allows Pratt to maintain his reference to visually perceived reality while emphasising the abstract and the mythic aspects of his subject.

33. Light — artificial and natural — was also the subject of his drawing *Lamp in the Window* (1968) (the traditional symbol of waiting and welcome) and *Light in the Middle of Nowhere* (1981).

34. Silcox, *Christopher Pratt*:103.

35. See also *Subdivision* and *Me and Bride* for other instances in which the artist rejects the idea of what he calls "exposure."

36. Silcox, *Christopher Pratt*: Preface.

37. "Pure form" was the goal established by William Carlos Williams in his poetry. See Rick Stewart's "Charles Sheeler, William Carlos Williams and Precisionism: A redefinition," *Arts Magazine*, Vol. 58 (November 1983): 105.

38. Bachelard, *The Poetics of Space*: 27.

39. Pratt was aware of Tooker's work before he left for Glasgow in 1957. He had clipped a reproduction of the painting *Subway* (1950). There are aspects of Tooker's anonymous figures in Pratt's early studies of Mary in the fish plant (*Women in a Fish Plant* [1959] and *Women Cleaning Fish* [1959]) where, forced to use the same model, Pratt gave each figure a uniform depersonalized character.

40. Faucets, door knobs, benches and messages on the bulletin board included in preliminary studies are all omitted.

41. Pratt most certainly knew this work in the collection of the Metropolitan Museum of Art which was reproduced as the first illustration in the Metropolitan Museum of Arts Miniatures series, *Contemporary American Painting* (Volume 93). In the volume, the author described the "astringent poetry" created from "visible aspects of America." He stressed the American tradition of realist art and its emphasis on a new beauty found in the directness of the urban statement.

42. David Silcox, "unpublished interview with Christopher Pratt": 12.

43. Silcox, *Christopher Pratt*:106.

44. Stewart, "Charles Sheeler, William Carlos Williams":100.

1. Though Mary did occasionally serve as Pratt's model in Glasgow and Mt. Allison when he was required to work from the figure for an assignment, Christopher believed that Mary's role as an artist in her own right precluded the kind of arrangement that prevailed for the Colvilles or the Hoppers in which the artist's wife was his model. Though Mary offered Christopher support, guidance and sometimes advice, time free from family responsibilities was spent in her studio. (Many of Pratt's models were, in fact, hired to assist with household chores and babysitting.)

2. Canadian Industries Limited.

3. Excerpt from "The Apples", c.1964, unpublished poem by Christopher Pratt.

4. "I feel professionally shortchanged when I can't paint the figure . . . I just enjoy the comprehension and articulation of the female figure infinitely more." David Silcox, unpublished interviews with Christopher Pratt: 25.

5. This abandoned 1964 print exists both in its original and in revised form. Recognizing its latent potential, in 1980 Pratt trimmed the print to focus on the image of the boys.

6. Piero della Francesca: Polyptych: *The Madonna and Child Enthroned, with Saints* (wood with 3 panels on the main tier, a single panel with *The Annunciation* above and 3 predella panels below). *St. Francis and St. Elizabeth* (124 x 64 cm).

7. John Sewell Flagg, *Prometheus Unbound and Hellas: An Approach to Shelley's Lyrical Dramas* (Salzburg: Institut für Englische Sprache und Literatur, 1972): 43-49.

8. "It was not enough to have the boy in the woods. *I* had to be there." Interview with the artist, March 6, 1985.

9. William Carlos Williams, *Selected Essays* (New York: Random House Inc. 1954): 197-198.

10. Painting in the United States during the 1920s and 1930s was dominated by regional concerns. Artists like Grant Wood and John Steuart Curry built their reputations on images which depicted the "American Scene." Their work portrayed the physical and human landscapes of rural America and works like Wood's *American Gothic* and Curry's *Baptism in Kansas* became popular images that exercised great appeal for the Canadian art world as well. Consciously "provincial," their work stressed content while rejecting abstract and formal concerns. Seeking what Thomas Hart Benton called "rehumanization" of American art, they deliberately rejected the idea of "art for art's sake."

11. Known to him from Paul Sach's *Modern Prints and Drawings* (New York: Alfred A. Knopf, 1954) and from the January 3, 1955 *Time* Magazine Vol. 65 No. 1, which reproduced *The Artist Looking at Nature* (1943), oil on canvas, (collection: The Art Institute of Chicago), that showed Sheeler seated in a landscape painting this interior scene.

12. Interview with the artist, March 3, 1985.

13. Williams, *Selected Essays*: 197-198.

14. For a discussion of these characteristics of American painting, see Barbara Novak, *American Painting of the Nineteenth Century* (New York: Harper & Row, 1979): 98.

15. Williams, *Selected Essays*: 212-213.

16. David Silcox, *Christopher Pratt* (Scarborough: Prentice-Hall Canada Inc., 1982): 182.

17. Charles Sheeler, "Notes on an Exhibition of Greek Art," *The Arts*, 8 (March, 1925): 153. Note the similarities between Sheeler's aesthetic intentions and those of Pratt.

18. George Santayana, *Three Philosophical Poets*, (Cambridge: Harvard University, 1910): 129-130.

19. Quoted by Merike Weiler in Silcox, *Christopher Pratt*: 185.

20. Interview with the artist, March 6, 1985.

21. The printshop in St. Michael's, Newfoundland was associated with the Extension Department of Memorial University. Don Holman was the master printer for the workshop.

22. First conceived with no specific model in mind, in the absence of a model, Mary posed for the early studies of this work; in the final stages, Yvonne, another model, posed for the figure and the preparatory drawings suggest the metamorphosis of the work as the model changed. Mary had been his model in Glasgow and at Mount Allison.

23. This work was reproduced on page 215 of Sach's, *Modern Prints and Drawings* and Pratt had hung a reproduction of it on his bulletin board.

24. Originally titled *Summer Place*, the working title for the print was *Nude by Night Window*.

25. Interview with the artist, March 6, 1985. The only remnant of the original interior setting is the fact that Pratt, who is right-handed, appears left-handed in the painting as he would in a reflection.

26. Quoted from *Christopher Pratt: Some Newfoundland Memories, Art Magazine*, Vol. 7 No. 25 (1976): 14.

27. Ingres' *Study for the Golden Age*, c.1842 (Fogg Museum) and Modigliani's *Seated Nude*, c. 1918 (Museum of Modern Art) were illustrated in Sach's *Modern Prints and Drawings* and Pratt copied the Ingres in his study of the nude figure.

28. Mary Pratt notes that Donna became a "partner in the business of making images of the human female figure." Letter to the author, July 1985.

29. Pablo Picasso, *The Painter and His Model* (1927), etching for Balzac's "Chef d'oeuvre inconnu," (Vollard, 1931), 19.4 x 28 cm. (Bloch no. 89).

30. Pablo Picasso, *Ape and Model* (1954), ink on paper, *Verve Suite*, 24.2 x 32.1 cm.

31. In a destroyed composition of Denise, *Young Model on a Mattress* (1984), the artist also abandoned the hitherto omnipresent planar, compositional format and the model was posed on the diagonal.

1. Vincent Scully "The Precisionist Strain in American Art" *Art in America*, Vol. 48 No. 3 (Fall 1960): 46.

2. Jean Laroche quoted by Gaston Bachelard in *The Poetics of Space* Maria Julis tr. (Boston: Beacon Press 1969): 55.

3. *Random House Dictionary*, (New York: Ballantine, 1978).

4. In Greek the term is KIBOTOS and in Latin, ARCA, according to Northrop Frye in *The Great Code* (Toronto: Academic Press, 1982): 177. The name of the reed bark that protected the infant Moses from the Pharoah's wrath was the "ark" which consequently became a symbol of rebirth in Christian symbolism, as was the larger vessel that brought Noah and his travellers safely through the flood.

5. David Silcox, "unpublished interviews with Christopher Pratt":1.

6. Ryder's work had been reproduced extensively in popular magazines and art magazines. e.g. *Arts* (*Artsmagazine*) Vol. 30 No.10, (July, 1956): 12, *Moonlight on the Sea*; *Arts* (*Artsmagazine*) Vol. 30 No.12, (September, 1956): 36, *The Tempest*; and in *Time* Magazine, Vol. 58 No. 26, (December 24, 1956): 32, *Toilers of the Sea*.

The Eakins reproduction may have been *The Paired Oar Shell* (1872), reproduced in Leslie Katz's "Thomas Eakins Now" *Arts* (*Artsmagazine*) Vol. 30 No.12, (September, 1956): 18, or *Max Schmitt in A Single Scull* (1871) reproduced in *Time* Magazine, Vol. 58 No. 26, (December 24, 1956): 31.

7. John Wilmerding has traced the evolution of the marine tradition through the early Dutch influence to the development of an indigenous American expression in the work of the Hudson River School, the Luminists, Winslow Homer and Albert Pinkham Ryder. John Wilmerding, *American Marine Painting*, (Richmond: The Virginia Museum, 1976).

8. Northrop Frye on E.J. Pratt, quoted by Patricia Jan Munro in her *Seas, Evolution and Images of Continuing Creation in English Canadian Poetry* (M.A. Thesis, Department of English, Simon Fraser University, 1970): 30.

9. Interview with the artist, May 7, 1984.

10. Quotations are from *The light is . . . white* and from *How Soon When the Day is White*. I am indebted to Victoria Evans for this insight.

11. It is likely that Pratt's interest in composition, already strong due to his background in architectural drafting and his Glasgow studies, was reinforced at this time by John Canaday's essay in *Composition as Structure*, Portfolio No. 6, in the "Metropolitan Seminars in Art," (New York: Metropolitan Museum of Art, 1958): 9.

12. Roland Barthes, *Mythologies* (London: Granada Publishing Ltd, 1973): 67.

13. The paint which Pratt used here was not as stable as that which he later employed and it had a certain waxiness to it. A number of these prints are today in very fragile condition — their colour has faded and is even flaking, depending upon their exposure to the air and light. The ordinary craft paper available at Mount Allison was not the best matrix to use. Pratt used rough water colour paper as well and that created a softer effect. He also printed a few on board at the time. For this reason many who consider the print to be soft browns and beiges do not realize that in the original state there was a dominant green.

14. Pratt's father would later begin to manufacture fibreglass boats in an attempt to assist in reactivating the fishing industry in Newfoundland.

15. Paul Valery's "Le Coquillages" in *Les merveilles de la mer*. Quoted by Bachelard in *The Poetics of Space*: 106.

16. See also Renoir's *Sailboats at Argenteuil* (1873-74), (Portland Art Museum, Oregon). Note that Monet painted an almost identical subject at the same time which is now in a private collection.

17. Charles Sheeler's *Pertaining to Yachts and Yachting* (1922) was reproduced in "The American Muse" *Arts* (*Artsmagazine*) Vol. 33 No. 8, (May 1959): 38-41. Charles Demuth, *Sailboats (The Love Letter)* (1919), (in the collection of the Santa Barbara Museum) tempera on board, 40.7 x 50.8 cm.

18. Note: *Sails* (1952), 76.2 x 61 cm., by Lawren P. Harris was reproduced in Douglas Lochhead "Lawren P. Harris — A Way to Abstract Painting" *Canadian Art* Vol. 12 No. 2, (Winter 1955): 64-67, which Pratt most certainly saw.

19. This was probably in late 1955 shortly before Pratt left Mt. Allison.

20. See also Colville's 1964 serigraph *Boat and Marker* for an earlier approach to this subject.

21. Pratt's first intention was to show the whole boat cutting through the water but then he moved it in closer. David Silcox, *Christopher Pratt* (Toronto: Quintus Press, 1981, deluxe edition): 59.

22. O'Keeffe suggests that this, her principal goal in painting was learned from Arthur Wesley Dow, her most important teacher.

23. At the Vancouver Art Gallery in 1972, and again at the Mira Godard Gallery in 1977. In 1972 Pratt began work on his first set of abstract collages associated with the prints series, the *Strait of Belle Isle*.

24. For example, the focus of *Lake Ontario* is a ship seen in the distance through a telescope. *Above Montreal* was based on a trip on the St. Lawrence.

25. The dimensions are similar but not identical. *New Boat* is 36.9 x 76.2 cm. and *Yacht Wintering* is 41.9 x 81 cm.

26. Pratt recalls visually adjusting and readjusting these pictorial elements, unaware of any representational or symbolic significance. Interview with the artist, March 7, 1984.

27. I recognize that these deal with different elements of Newfoundland society and that Hartley, like numerous others, including David Blackwood, has responded, in his art, to the despair of the fisherman. Nevertheless in larger terms, each of these artworks, be it about Vikings or the local fishing family, is about the sea and about boats and about eternal life as well as death. Pratt remains concerned with such legends in his poetry and one of his most recent poems was written to commemorate the sinking of that supposedly invincible craft, the "Ocean Ranger."

1. Quoted in David Silcox's "unpublished interview with Christopher Pratt": 4.

2. Gaston Bachelard, *On Poetic Imagination and Reverie*, (Indianapolis: The Bobbs-Merrill Co., 1971): 23.

3. Pratt has often said that, should he be forced to choose between the west coast sea, with its mountains and dense forests, and prairie life, he would choose the prairies, in spite of his deep need to be near the sea.

4. In his 1982 poem, *Ocean Ranger*, he described the fiery sea as "monstrous dehydrated plains of ancient grain."

5. As it would in his poetry of the same period. See *The Light is White*. (Unpublished and undated poem by Christopher Pratt.)

6. *Crow and Raven*, unusual in Pratt's work for its angled viewpoint and its naturalistic patterning of the birds against the rocks, was a memorial for a friend who had died. The cod and seal on the Newfoundland stamps had already acquired symbolic functions when Pratt transferred the images from stamp to print.

7. Interview with the artist May 8,1984.

8. Gaston Bachelard, *Water and Dreams* (Dallas: The Pegasus Foundation, 1983): 35.

9. In an untitled poem, Pratt wrote: "For all are weightless in the sea . . . Only on the land/ Out of context of the environment/ Is weight a quantity." In other poems he speaks about that darkness below the transparent surface of the deep. Pratt is clearly bound up with the nature of the sea and its mystery.

10. Untitled poem. Italics this author's.

11. Barbara Novak. *American Painting of the Nineteenth Century* (New York: Harper & Row, 1979): 96-97.

12. Pratt relies on spacing of parallel bands of colour to create a sense of depth. His Glasgow teacher, Miss Dick, insistent on the need for proper perspective, would have argued that in this work "we are too suddenly there."

13. Michael Greenwood, "Christopher Pratt," *artscanada*, Vol. 33 No. 4, (December 1976/January 1977): 31.

1. Gaston Bachelard, *On Poetic Imagination and Reverie* (Indianapolis: The Bobbs-Merrill Co., 1971): 104.

2. David Silcox, *Christopher Pratt* (Scarborough: Prentice-Hall Canada Inc., 1982): 24.

3. As described to the author in an interview with the artist, May 16, 1984. (Note: A "flensing knife" is a knife used to strip fat or blubber.)

4. Letter to the author, July 4, 1985.

5. Joseph Conrad, *The Nigger of the Narcissus* (Garden City, N.Y.: Doubleday Page & Co., 1922): 8. See also F.R. Leavis who suggests this book parallels Coleridge's *Rime of the Ancient Mariner* in its preoccupation with suspended motion that is reminiscent of the lethal stillness that is "death-in-life". F.R. Leavis, *The Great Tradition, George Eliot, Henry James, James Conrad* (London: Chatto & Windus, 1962): 187. Notice also that *Yacht Wintering*, (sombre in colour, like *Whaling Station*) is, like the becalmed *Narcissus*, unnaturally immobilized. Though Pratt did, at one time, read *The Nigger of The "Narcissus"*, it is not my intention to suggest any direct connection but rather to point out the difference in their approach to imagery.

6. In a note to the author, July 4, 1985, Pratt acknowledges that this was an option for the "major" panel of *Federal Area*. At the time, he had thought of letting it stand alone, but he adds "I suppose at the time I wasn't ready for that." (Argentia, the inspiration for *Federal Area* gave the artist his first direct connection with "bunk houses," construction camps and total regimentation.) As I have noted, in discussion of the painting *Me and Bride*, the artist's decision to move the setting out of doors onto a porch began the step of merging interior and exterior space.

1935
Born John Christopher Pratt, St. John's, Newfoundland, December 9. Parents John Kerr and Christine Emily (Dawe) Pratt.
Close ties with Grandfather, James C. Pratt who began painting as a hobby after his 65th birthday in 1945.

1939-46
Holloway Primary School, St. John's.
Summers spent at Topsail and Bay Roberts.

1946-52
Prince of Wales College Secondary School, St. John's.
Summers spent at Bay Roberts, Ocean Pond and Placentia.

1952 Fall
Memorial University of Newfoundland, St. John's, pre-engineering.

1953 Spring
Wins Government of Newfoundland Arts and Letters Competition for the watercolour, *Shed in a Storm*.

1953 Fall
Mount Allison University, Sackville, N.B. medical studies. Accepted as a "special student" at the School of Fine Arts by Lawren Harris Junior, Ted Pulford and Alex Colville. Meets Mary West (then a Fine Arts student in her first year).

1954 Spring
Wins Government of Newfoundland Arts and Letters Competition for the watercolour painting *The Bait Rocks* and for poetry.

1954 Fall
Mount Allison University: Enrolls in Faculty of Arts. Wins University literary competition for poetry and short story categories.

1955 August
Mary visits with Pratts in Newfoundland.

1955 December
Quits Mount Allison and returns to St. John's to paint full-time.

1956 Winter-Summer
Works at construction of summer cabin at south east Placentia. Spends a lot of time on "Cape Shore".

1956 Spring
Travels with Aunt to New York. Visits all the major galleries. Continues to paint and manages to sell about a painting a week. Visits Toronto on the way home (Ontario College of Art and the University of Toronto).

1956 May
Mary moves to St. John's and begins work as a therapist.

1957
Sept. 12 Pratts married in Fredericton.
Sept. 14 Pratts sail for Liverpool.
Oct. 1 Pratt enrolls at Glasgow School of Art.

1957-58
Glasgow School of Art-Foundation year programme. Important direction from Jessie Alix Dick, Head of Foundation year programme. Pratt returns home to work in Newfoundland during the summers (as a construction surveyor at Argentia Naval Station).

1958
Son John born.

1959-61
Pratts study at Mt. Allison School of Fine Arts, Sackville.

1960
Daughter Anne born.

1960
Jury selects *Boat in Sand* for National Gallery of Canada Biennial. Exhibits in "Young Contemporaries" show, London, Ontario.

1961 Spring
Wins Purchase Award for *Demolitions on the South Side* at Atlantic Awards Exhibition, Dalhousie University.
Christopher and Mary graduate with B.F.A. Move to St. John's. Pratt becomes Specialist in Art at Memorial University, teaches extension classes there at night and runs the art gallery.

1961 Fall
Juror, "Young Contemporaries", London, Ontario, meets Jack Chambers, Tony Urquhart, etc.

1963
Daughter Barbara born.
Pratt quits Memorial University position to paint full-time. Moves to St. Catherine's, St. Mary's Bay. Sets up home in old summer house owned by his father.

1965
First solo exhibition organized by Memorial University and toured on Atlantic Provinces Art Circuit.
Son Edwyn born. Becomes A.R.C.A. Associate of the Royal Canadian Academy. Member, Canadian Society of Graphic Art.

1965-72
Annual summer trips to Labrador aboard yacht "Hemmer Jane", with father, brother Philip, Uncle Chester Dawe, F.N. Clarke, and David Silcox.

1969
Travelled across Canada with Canada Council Visual Arts jury, including David Silcox, Ulysse Comtois, Dorothy Cameron. Meets many of his contemporaries for the first time, i.e. Iain Baxter, Greg Curnoe, Claude Breeze, Charles Gagnon, Yves Gaucher, Brian Fisher etc. (Met Mira Godard for first time on this trip.) Sole juror for "Calgary Graphics Exhibition".

1972
Hon. D. Litt. Mount Allison University, N.B., awarded by Lawren P. Harris. Hon. D. Laws, Memorial University, Newfoundland.
Stamp design committee with David Silcox, Charles Gagnon, Allen Fleming, Doris Shadbolt.

1973
Officer of the Order of Canada.

1975-81
Member of the Board, Canada Council.

1980
Designs the flag for the province of Newfoundland.

1982
Publication David Silcox, *Christopher Pratt* (Scarborough: Prentice-Hall, 1982).

1983
Companion of the Order of Canada.

COLLECTIONS

Art Gallery of Hamilton
Art Gallery of Ontario, Toronto
Bank of Montreal Collection
Bank of Nova Scotia Collection
Beaverbrook Art Gallery, Fredericton
The Canada Council Art Bank, Ottawa
C.I.L. Collection, Montreal
Clarkson Gordon Collection, Vancouver
Confederation Art Gallery, Charlottetown
Dalhousie University, Halifax
Department of External Affairs, Ottawa
Hamilton Regional Art Gallery
Imperial Oil Collection
Lavalin Inc., Montreal
London Regional Art Gallery
Memorial University, St. John's
Mendel Art Gallery, Saskatoon
Mount Allison University, Sackville
Musée d'art contemporain, Montreal
National Gallery of Canada, Ottawa
New Brunswick Museum, St. John
Northern and Central Gas Collection
Polysar, Sarnia
Regina Public Library
Secal-Alcan, Montreal
Shell Canada Collection
University of Moncton
Vancouver Art Gallery
York University Collection, Toronto

LIST OF EXHIBITIONS

Solo exhibitions

1965
Memorial University Art Gallery, toured through the Atlantic Provinces Art Circuit.

1966
Exhibition of Paintings, Drawings and Prints by Christopher Pratt, Atlantic Provinces Art Circuit.

1970
Memorial University Art Gallery, in collaboration with Galerie Godard Lefort, Montreal.

Godard Lefort Gallery, Vancouver.

Marlborough Godard Gallery, Montreal.

1972
Memorial University Art Gallery, St. John's.

1972-73
Atlantic Provinces Art Circuit.

1973
Christopher Pratt Serigraphs, Beaverbrook Art Gallery, Fredericton.

1974
Marlborough Godard Gallery, Toronto.

1976
Marlborough-Godard Gallery, Montreal; Marlborough-Godard Gallery, Toronto; Marlborough Gallery, New York.

1978
March Crossing and Proofs: an exhibition of recent screenprints, related collages and stencil proofs, Mira Godard Gallery, Toronto, Mira Godard Gallery, Montreal.

1980
Mira Godard Gallery, Toronto.

1980-81
Christopher Pratt: Prints, Related Stencils, Collages, Stencil Proofs 1975-80, Memorial University Art Gallery, travelled through the Atlantic Provinces.

1982
Mira Godard Gallery, Toronto.

1982-83
Christopher Pratt Paintings, Prints and Drawings, Canadian Cultural Centre Gallery, London, England. Travelled to Paris, Brussels and Dublin.

1983
Mira Godard Gallery, Calgary.

1983-84
Canadian Cultural Centre Gallery, London, England. Travelled to Rome, Glasgow, Billingham, Berkshire, Dublin and Vienna.

1984
Mira Godard Gallery, Toronto. Centro di Cultural di Palazzo Grassi, Venice, Italy.

Group Shows

1961-67
Atlantic Awards Exhibition, Dalhousie Art Gallery, Dalhousie University, Halifax.

1961
Fourth Biennial Exhibition of Canadian Art, National Gallery of Canada, Ottawa.

Calgary Graphics Exhibition, Calgary (Successive Exhibitions).

Atlantic Awards Exhibition, Atlantic Provinces Art Circuit.

Eighth Annual *Young Contemporary Painters*, London Public Libraries and Museums, London, Ontario.

1962
First Biennial Winnipeg Show, Winnipeg Art Gallery, Winnipeg.

1963
Fifth Biennial Exhibition of Canadian Art, National Gallery of Canada, Ottawa.

Winnipeg Exposition, Winnipeg Art Gallery, Winnipeg.

Young Contemporary Painters, London Public Libraries and Museums, London, Ontario.

1965
32nd Annual Exhibition, Sarnia Library & Art Gallery, Sarnia, Ontario.

Atlantic Awards Exhibition, Atlantic Provinces Art Circuit.

Fifth Annual Calgary Graphics Exhibition, Calgary.

1966
Magic Realism in Canadian Painting, London Public Libraries and Museums, London, Ontario.

Tenth Winnipeg Show, Winnipeg Art Gallery, Winnipeg.

Artists of Atlantic Canada, Atlantic Provinces Art Circuit.

1967
Atlantic Provinces Pavilion, Expo '67, Montreal.

Second Atlantic Awards Exposition, Dalhousie Art Gallery, Halifax.

Artists of Atlantic Canada, Atlantic Provinces Art Circuit.

1968
Spring Exhibition, Agnes Etherington Art Centre, Kingston, Ontario.

1971

Artists of Atlantic Canada, Atlantic Provinces Art Circuit.

Canadian Society of Graphic Art, Touring Exhibition, Oshawa/Washington.

Painters in Newfoundland, Memorial University Art Gallery. Organized by Peter Bell in collaboration with the Picture Loan Society, Toronto.

1972

London Collects, London Public Libraries and Museums, London, Ontario.

Yves Gaucher and Christopher Pratt, Vancouver Art Gallery. (A touring exhibition.)

1973

Canada Trajectoire, Musée d'art Moderne, Paris, France.

Women's Committee Sponsored Exhibition and Sale of International Prints, London Public Libraries and Museums, London, Ontario.

1974

Colville, Pratt, and Forestall, Beaverbrook Art Gallery, Fredericton.

Artist's Stamps and Stamp Images, International invitational exhibition, Simon Fraser University Gallery, Vancouver.

The Acute Image in Canadian Art, Owens Art Gallery, Mount Allison University, Sackville, New Brunswick.

D.P. Brown, Ken Danby, Tom Forrestall, Christopher Pratt, Centre Culturel Canadien, Paris; Centre Culturel et d'information, Bruxelles; Canada House Gallery, London, England.

Magic Realism, The Owens Art Gallery, Mount Allison University, Sackville, New Brunswick.

Thirteen Artists from Marlborough-Godard, Marlborough-Godard, Montreal; Marlborough, New York.

1975

The Canadian Canvas, a travelling exhibition of 85 recent paintings. Initiated and sponsored by Time Canada.

1975-76

Images of Women, The Winnipeg Art Gallery, Winnipeg.

The Wallace S. Bird Collection, Beaverbrook Art Gallery, Fredericton; Mendel Art Gallery and Conservatory, Saskatchewan; Art Gallery of Nova Scotia, Halifax; New Brunswick Museum, St. John; Memorial University Art Gallery, St. John's.

1976

Acquisitions to the Permanent Collection, Norman Mackenzie Art Gallery, Regina.

Twenty Canadians, Douglas Gallery, Vancouver.

Atlantic Graphics, Beaverbrook Art Gallery, Fredericton.

Changing Visions: The Canadian Landscape, The Edmonton Art Gallery and the Art Gallery of Ontario.

1976-78

Aspects of Realism. (Sponsored and organized by Rothman's of Pall Mall Canada Ltd. A trans-Canada exhibition.)

1977

Yves Gaucher and Christopher Pratt. A touring exhibition of prints, Vancouver Art Gallery and Mira Godard Gallery, Toronto.

Equinox Gallery, Vancouver, B.C.

1978

Coast, Sea and Canadian Art, Stratford Art Gallery, Ontario.

Modern Painting in Canada: A Survey of the Major Movements in 20th Century Canadian Art, Edmonton Art Gallery.

1979

Twentieth Century Canadian Drawings, Stratford Art Gallery, Ontario.

1979-80

Aspects of Canadian Printmaking. A travelling exhibition organized by the Mira Godard Gallery, Toronto.

1980

Aspects of Canadian Painting in the Seventies, Glenbow Museum, Calgary.

University of Guelph: the Collection, Guelph, Ontario.

1981

Correspondences, a travelling exhibition organized by the Walter Phillips Gallery, Banff School of Fine Arts, Alberta.

1983

The Nude in Canadian Art, The Pagurian Gallery, Toronto.

1984

Alex Colville/Christopher Pratt/Jeremy Smith, Galerie Mihalis, Montreal. A collection of original screen-prints.

CATALOGUES AND BOOKS

Burnett, David and Marilyn Schiff. *Contemporary Canadian Art*. Edmonton: Hurtig; Toronto: in cooperation with the Art Gallery of Ontario, 1983.

Duval, Paul. *High Realism in Canada*. Toronto: Clarke, Irwin Ltd., 1974.

Edmonton Art Gallery. *Changing Visions: The Canadian Landscape*. Edmonton, Alberta: Edmonton Art Gallery, 1976.

Fenton, Terry and Karen Wilkin. *Modern Painting in Canada*. Edmonton, Alberta: Edmonton Art Gallery, 1978.

Glenbow-Alberta Institute. *Aspects of Canadian Painting in the Seventies*. Calgary, Alberta: Glenbow-Alberta Institute, 1980.

Greenwood, Michael. *Christopher Pratt*. Toronto: Marlborough Godard Ltd., 1976.

_____. *Christopher Pratt: Paintings, Prints, Drawings*. London, England: Canadian High Commission, 1982.

Heath, Terrence. "A Sense of Place" in Robert Bringhurst, Geoffrey James, Russell Keziere, and Doris Shadbolt eds. *Visions: Contemporary Art in Canada*. Vancouver/Toronto: Douglas and McIntyre, 1983.

London Public Libraries and Museums. *Magic Realism in Canadian Painting*. London, Ontario: London Public Libraries and Museums, 1966.

Marlborough Godard Ltd. *Thirteen Artists*. Toronto: Marlborough Godard Ltd., 1974.

Mira Godard Gallery. *Christopher Pratt: March Crossing and Proofs*. Toronto/Montreal: Mira Godard Gallery, 1978.

Morris, Jerrold A. *The Nude in Canadian Painting*. Toronto: New Press, 1972.

_____. *One Hundred Years of Canadian Drawings*. Toronto: Methuen, 1980.

Morrison, Ann. *Yves Gaucher and Christopher Pratt*. Vancouver: Vancouver Art Gallery, 1977.

Owens Art Gallery. *The Acute Image in Canadian Art*. Sackville, N.B.: Owens Art Gallery, Mount Allison University, 1974.

Reid, Dennis. *A Concise History of Canadian Painting*. Toronto: Oxford University Press, 1973.

Rothmans of Pall Mall Canada Ltd. *Aspects of Realism*. Toronto: Rothmans of Pall Mall Canada Ltd., 1976.

Shadbolt, Doris. *Christopher Pratt*. St. John's: The Art Gallery, Memorial University of Newfoundland, 1970.

Silcox, David P. *Christopher Pratt: Prints, Related Studies, Collages, Stencil Proofs 1975-1980*. St. John's: The Art Gallery, Memorial University of Newfoundland, 1980.

―――― and Merike Weiler. *Christopher Pratt*. Scarborough, Ontario: Prentice Hall Canada, 1982.

Simon Fraser University. *Artists' Stamps and Stamp Images*. Burnaby, B.C.: Simon Fraser University, 1974.

Time Canada Ltd. *The Canadian Canvas*. Toronto: Time Canada Ltd., 1974.

PERIODICALS AND REVIEWS

Anand, Morgan. "Mary and Christopher Pratt." *Newfoundland Life Style* 2, no. 2 (1984): 24-27.

"Art Exhibitions Open at Museum Wednesday." *Evening Times Globe*, St. John, New Brunswick (April 2, 1972). (Working drawings and preliminary sketches for the major serigraph of the period.)

"Art Gallery can serve many functions — Artist." *Chronicle-Herald*, Halifax, Nova Scotia (October 21, 1971). (Paraphrases Pratt's address to Mount Allison University's fall convocation. Pratt had received an honorary Doctor of Letter degree at Mount Allison's spring convocation.)

"Artist here honoured." *Evening Telegram*, St. John's, Newfoundland (November 25, 1965). (Pratt received the A.R.C.A.)

"Artist to receive honorary degree." *Corner-Brook Western Star*, Newfoundland (October 11, 1972).

Ayre, Robert. "The Fourth Biennial Exhibition." *The Montreal Star* (May 27, 1961). (Illustrated with Pratt's print *Boat in Sand*. Pratt has written at the top of the clipping: "First time anything of mine was reproduced.")

Ball, Denise. "Artist wants to dispel Myths." *The Leader Post*, Regina (April 7, 1982).

Bandes, Lucille. "Christopher Pratt's Haunted Realism." *Officiel*, vol. 1, no. 3 (Spring 1977): 126-131.

Bell, Jane. "13 Artists from Marlborough-Godard." *artsmagazine*, vol. 49, no.3 (November 1974): 4.

Bell, Peter. "The Pratt Exhibition." *Evening Telegram*, St. John's, Newfoundland (June 15, 1974).

――――. "Painters of Newfoundland." *Canadian Antiques Collector*, vol. 10, no. 2 (1975): 62-65. (Part of a special Newfoundland issue.)

――――. "The Visual Arts in Newfoundland." *Arts Atlantic*, vol. 1, no. 1 (Fall 1977): 10-13.

――――. "Unusual exhibition contrasts artists." *Evening Telegram*, St. John's, Newfoundland (January 28, 1978).

Benedict, Michael. "Honorary degree conferred on artist Christopher Pratt." *Evening Telegram*, St. John's, Newfoundland (May 26, 1972).

Bodolai, Joe. "A Visit to Newfoundland." *artscanada*, 202/203 (Winter 1975-76): 41-47.

Bowen, Lisa Balfour. "Pratt paintings rare and expensive." *Toronto Star* (December 6, 1980).

Bruce, Harry. "Christopher Pratt: Magic and Reality." *Maclean's*, 86, no. 12 (December 1973): 36-46.

――――. "A Rarer Reality: Christopher Pratt invests everyday objects with mystery." *The Canadian Magazine* (November 26, 1977).

Carroll, Nancy. "Painting, seeing and Christopher Pratt." *Vanguard*, vol. 11, no. 1 (February 1982): 17-19.

Casselman, Karen. "Colville, Pratt, Forrestall are Fine, but what about Morton, Climo, McKay?" *Atlantic Insight* (May 1979): 52-53.

Cherry, Zena. "The Shellback dinner is boat show highlight." *Globe and Mail* (January 13, 1982). (Yachting club dinner at which Pratt was the guest speaker.)

"Christopher Pratt awarded degree." *Daily News*, St.John's, Newfoundland (May 26, 1972).

"Christopher Pratt wins $500 for Art." *Daily News*, St. John's, Newfoundland (April 1, 1961). (Pratt won the second prize for *Demolitions on the South Side* in the first Atlantic Awards Exhibition.)

Cook, Michael. "Christopher Pratt: Passionate Realist." *Evening Telegram*, St. John's, Newfoundland (December 20, 1968).

――――. "Christopher Pratt: tel qu'en lui-même." *Vie des Arts*, 22, no. 87 (Summer 1977): 42-44, English text 89-90.

"Couple of Good Friends." *Edmonton Journal* (April 24, 1983). (On Christopher and Mary Pratt.)

Dault, Gary Michael. "Maritime Artist more than a Realist." *Toronto Star* (October 25, 1976).

"Exhibit at Acadia." *Halifax Mail Star*, Nova Scotia (February 9, 1981). (Show of Pratt prints and related drawings.)

Felter, J.W. "Artists' Stamps and Stamp Images." *artmagazine*, 8, no. 29 (October/November 1976): 47-49.

"Focus on Art — Pratt-Gaucher link is strong." *Brantford Expositor* (June 10, 1978).

Freedman, Adele. "What You see Isn't What you Get." *Toronto Life* (April 1979): 189.

――――. "A world through the narrows: Christopher Pratt's St. John's." *Globe and Mail* (March 20, 1982).

Grattan, Patricia. "Update: Memorial University Art Gallery." *Arts Atlantic*, 12 (Spring 1979): 9.

Greenwood, Michael. "The Canadian Canvas." *artscanada* (March 1975): 1-16.

――――. "Current Representational Art: Christopher Pratt." *artscanada*, nos. 210-211 (December 1976-January 1977): 30-33.

Gwyn, Sandra. "The Newfoundland Renaissance." *Saturday Night* 91 (April 1976): 38-45.

Hale, Barrie. "Fine Art's Finest: The Powers Behind Canadian Art." *Toronto Star, Canadian Magazine* (March 29, 1975).

Hammock, Virgil G. "Pratt et Pratt." *Vie des Arts*, 26, no. 103 (Summer 1981): 45-48, English text 78-79.

Hay, Norman. "Canadian Artists — the Tough Go of Making it in New York." *Ottawa Citizen* (December 13, 1975).

Hume, Christopher. "Portrait of Painter Pratt at ease." *Toronto Star* (September 29, 1982).

"I knock on a door — and there are the people I meet." *Daily News*, St. John's, Newfoundland (February 28, 1953). (Early comments on Pratt's work.)

Innes, Lorna. "From Newfoundland Home, Pratt Casts influence on Canadian art." *Halifax Mail Star*, Nova Scotia (October 9, 1982).

Johnston, Ann. "A Brooding Vision." *Maclean's*, 94, no. 38 (September 21, 1981): 36-40.

Jones, Sarah. "Artist uses land to portray a theme." *Medicine Hat News*, Alberta (April 12, 1980).

Kritzwiser, Kay. "Paintings with disciplined serenity: right-angled rectitude." *Globe and Mail* (January 19, 1974). (Review of a Pratt show at Marlborough-Godard, Toronto.)

――――. "Book Review: Christopher Pratt by D.P. Silcox." *artmagazine*, 14, no. 61 (December 1982-January/February 1983): 58.

Kucherawy, Dennis. "Newfoundland artist enriches reality." *London Evening Free Press*, Ontario (April 27, 1979).

――――. "Concert Probes Interrelationship of Arts." *London Evening Free Press*, Ontario (April 30, 1979). (Pratt's poetry set to music with dance.)

Lehman, Henry. "A Choice of Vision." *Montreal Star* (September 18, 1976).

Littman, Sol. "Artist's Passion is Tidiness." *Toronto Star* (January 18, 1974).

"Local Artist has harsh criticism of Industry." *Evening Telegram*, St. John's, Newfoundland (November 17, 1976).

Lowndes, Joan. "Christopher Pratt." *Vancouver Sun* (October 30, 1970).

———. "Rugged Maritimer travels own artistic trails." *Vancouver Sun* (October 30, 1970).

Mays, John Bentley. "Pratt's precise offerings reward the patient viewer." *Globe and Mail* (December 13, 1980).

Morrison, Ann. "Prints Yves Gaucher, Christopher Pratt." *Vanguard*, vol. 6, no. 4 (May 1977): 16.

"Newfoundland artist receives high merit in showing." *Daily News*, St. John's, Newfoundland (April 12, 1951).

Nixon, Virginia Lee. "Art — Artist's Notebook will sell for $2,100." *Montreal Gazette* (July 26, 1980).

Paradis, Andrée. "Peintres Canadiens Actuels." *Vie des Arts*, 20, no. 78 (Printemps/Spring 1975): 55.

Perlin, Rae. "Pratt receives first one man show." *Evening Telegram*, St. John's, Newfoundland (February 7, 1966).

"Pratt commissioned by Canada Council." *Saint John's News* (May 2, 1978).

"Pratt never paints from photographs." *Moncton Transcript*, New Brunswick (February, 1981).

"Pratt will attend opening of his St. Mary's exhibit." *Halifax Mail Star*, Nova Scotia (May 22, 1981).

"Pratt's art in a limited edition book." *Globe and Mail* (June 23, 1984).

Purdie, James. "Art — Pratt wants to leave the realist pack." *Globe and Mail* (October 20, 1976).

———. "Pratt practices his art of smaller, excellent parts." *Globe and Mail* (May 19, 1978).

———. "Review." *Globe and Mail* (May 19, 1978).

———. "Survey of Prints superlative show." *Globe and Mail* (July 25, 1978).

Reeves, John. "Christopher Pratt — Photographic Essays and Words." *artscanada* 27, nos. 148-149 (October/November 1970): 63-67.

———. "The Sea, the Wind and the Summer Sun." *Saturday Night* 92, no. 3 (April 1977). (Christopher Pratt and John Long on Sailing.)

"Rock Steady Hand molds Nude Figures." *Globe and Mail* (May 15, 1982).

Skoggard, Ross. "Reviews: New York." *Artforum*, 15, no. 6 (February 1977): 64-65. (Review of a Pratt show at the Marlborough Gallery, New York.)

"Special Exhibit of Graphic Art." *Chronicle-Herald*, Halifax, Nova Scotia (December 6, 1977).

"St. John's Artist to Instruct in Painting." *Saint John's Telegram*, Newfoundland (September 2, 1960).

"The Arts — Life Without Evasion." *Time Canada* vol. 88, no. 6 (August 5, 1966).

Thurston, Harry. "Pratt and Pratt, Christopher and Mary: The First Couple of Canadian Contemporary Art." *Equinox* (March/April 1982): 71-83.

Tindal, Doug. "Book review: Christopher Pratt." *Atlantic Insight*, 2, no. 3 (April 1980): 76-78.

Tousley, Nancy. "Correspondences: Sharing, not just showing." *The Calgary Herald* (August 13, 1981). (Review of a group show that included Pratt.)

———. "Pratt: Painting by Newfoundland artist Unveiled Here." *The Calgary Herald* (January 8, 1983).

"Two Newfoundlanders named to Order of Canada." *Evening Telegram*, St. John's, Newfoundland (December 22, 1972).

Walters, Ed. "In the tradition of E.J. Pratt — making something from nothing." *Kingston Whig-Standard* (August 29, 1980).

———. "Maritime artists sailing to Fame." *Vancouver Sun* (September 4, 1980).

Webb, Marshall. "Christopher Pratt at Mira Godard." *artmagazine*, 12, no. 53 (May/June 1981): 56-57.

Weiler, Merike. "Some Newfoundland Memories." *artmagazine*, 7, no. 25 (March/April 1976): 14-16.

Wilson, Trish. "In Praise of Prints: Danby, Pratt Exhibit Dispels Some Misconceptions of an Intricate Art Form." *Kitchener-Waterloo Record* (September 4, 1981). (Review of Christopher Pratt: Prints, Related Studies, Collages, Stencil Proofs 1975-1980.)

Woods, Kay. "Toronto — Showcase of East and West." *Arts West*, 7, no. 4 (April 1982): 22.

Yaffe, Barbara. "Newfoundland's great flag debate grounded for at least six months." *Globe and Mail* (May 17, 1980).

Yates, Sarah. "The Canadian Influence in Paris." *artmagazine*, 9, no. 35 (October/November 1977): 22-26.

1966

A Pratt interview conducted by Rae Perlin (*Evening Telegram*, St. John's, Newfoundland) and Jim Hiller (*Daily News*, St. John's, Newfoundland) was partially re-printed on the notice issued by the Atlantic Provinces Art Circuit announcing the artist's solo show of this year.

1976

Excerpts from a Pratt interview with Merike Weiler: "Some Newfoundland Memories" were published in *artmagazine*, vol. 7 no. 25 (March 1976): 14-16.

1978

A series of statements taken from Pratt's correspondence with the Mira Godard Gallery were re-printed in the catalogue of the *March Crossing and Proofs* show, held in the spring of 1978. The original letters were dated as follows: February 3, 1973; September 22, 1975; August 18, 1976; January 2, 1978; February 6, 1978; January 2, 1980.

1979

A taped interview involving the artist and L. Kricarrissian is available in the audio-visual centre of the Art Gallery of Ontario.

1982

Selected remarks from a "recent inverview" with Merike Weiler were incorporated into the text of David Silcox's *Christopher Pratt* (Scarborough, Ontario: Prentice-Hall Canada, Inc., 1982).

1982

Unpublished interviews with the artist compiled by David Silcox in conjunction with his research for the book, *Christopher Pratt*.

1984

Pratt's comments upon several pictures included in the *Christopher Pratt: Interiors* show (November, 1984) were used to preface the accompanying catalogue. Dating from May 1983, October 1983, April 1984 and June 1984, these discussions, which describe the genesis of four of the exhibited works, were culled from Pratt's written exchanges with the Mira Godard Gallery.

PAINTINGS

DEMOLITIONS ON THE SOUTH SIDE
1960 oil on canvas 46 x 102 cm
Collection of Dalhousie Art Gallery. Purchased in
1961 with a Canada Council Matching Grant

SELF PORTRAIT
1961 oil on canvas 76.4 x 102cm
Collection of Owens Art Gallery, Mt. Allison University, Sackville

HOUSE AND BARN
1962 oil on masonite 39.4 x 89.5 cm
Collection of the Department of External Affairs,
Ottawa

WOMAN AT A DRESSER
1964 oil on masonite 67 x 76.2 cm
Collection of the C.I.L. Collection, Montreal

WOMAN AT A STOVE
1965 oil on masonite 76.2 x 61 cm
Collection of Memorial University Art Gallery,
St. John's

YOUNG GIRL WITH SEA SHELLS
1965 oil on masonite 71.2 x 46.4 cm
Collection of Memorial University Art Gallery,
St. John's

YOUNG WOMAN DRESSING
1966 oil on masonite 94.6 x 54.3 cm
Collection of Mrs. Christine Pratt

YOUNG WOMAN WITH A SLIP
1967 oil on masonite 85.6 x 57.2 cm
Collection of the Art Gallery of Hamilton. Gift of
the Women's Committee and Wintario 1978

THREE O'CLOCK
1968 oil on masonite 39.4 x 45.7 cm
Collection of Mr. and Mrs Irving Ungerman

SHOP ON SUNDAY
1968 oil on masonite 28 x 48.3 cm
Collection of the Department of External Affairs,
Ottawa

HOUSE IN AUGUST
1969 oil on masonite 44.5 x 62.2 cm
Collection of Mr. and Mrs. William Teron

SHOP ON AN ISLAND
1969 oil on masonite 81.3 x 91.4 cm
Collection of the London Regional Art Gallery, on
permanent loan from the Ontario Heritage Foundation. Gift of Mr. J.H. Moore, London, 1979

WINDOW ON THE STAIR
1969 oil on masonite 101.6 x 60.9 cm
Collection of the Vancouver Art Gallery. Canada
Council Matching Grant and Murrin Bequest

WINDOW WITH A BLIND
1970 oil on masonite 121.9 x 61 cm
Collection of Norcen Energy Resources Limited,
Toronto

NIGHT WINDOW
1971 oil on masonite 115.6 x 75.6 cm
Collection of the Art Gallery of York University,
North York, Ontario

THE BED
1972 oil on masonite 86.4 x 69.3 cm
Collection of the Beaverbrook Art Gallery, Fredericton. Wallace S. Bird Memorial Collection, Gift
of the Beaverbrook Canadian Foundation

PORCH LIGHT
1972 oil on masonite 81 x 60cm
Collection of Mrs. Christine Pratt

STATION
1972 oil on masonite 85.1 x 138.2 cm
Collection of Confederation Centre Art Gallery
and Museum, Charlottetown. Purchased with
funds donated by the late Dr. Eric L. Harvie,
Calgary, Alberta

BAY
1972 oil on masonite 79.7 x 179.1 cm
Private collection

COTTAGE
1973 oil on masonite 67.3 x 121.9 cm
Collection of Lois and Kenneth Lund

***COLEY'S POINT**
1973 oil on masonite 66.8 x 106.7cm
Collection of James Fleck

INSTITUTION
1973 oil on masonite 76.2 x 76.2 cm
Collection of The National Gallery of Canada/
Musée des beaux-arts du Canada, Ottawa

***LANDING**
1973 oil on masonite 76.2 x 96.5 cm
Private collection

SUBDIVISION
1973 oil on masonite 65.1 x 90.2 cm
Collection of Lavalin Inc., Montreal

PARISH HALL
1974 oil on masonite 80 x 152.5 cm
Private collection

FEDERAL AREA
1975 oil on masonite 80 x 173.7 cm
Collection of Mr. and Mrs. J. Lazare

SUMMER PLACE
1975-78 oil on masonite 59.4 x 64.2 cm
Collection of Mira Godard

MARCH NIGHT
1976 oil on masonite 101.4 x 228.6 cm
Collection of the Art Gallery of Ontario, Toronto.
Purchased with assistance from Wintario, 1977

APARTMENT
1976 oil on masonite 74.9 x 121.9 cm
Collection of George R. Gardiner

ME AND BRIDE
1977-80 oil on masonite 113.1 x 273.1 cm
Private collection

THE VISITOR
1977 oil on masonite 94.5 x 226 cm
Collection of The National Gallery of Canada/
Musée des beaux-arts du Canada, Ottawa

BASEMENT FLAT
1978 oil on masonite 106.7 x 106.7cm
Collection of Lavalin Inc., Montreal

EXIT
1978-79 oil on masonite 131.8 x 81.3 cm
Collection of Polysar Limited, Sarnia, Ontario

TRUNK
1979-80 oil on masonite 92.7 x 106.7 cm
Private collection

BED AND BLIND
1980-81 oil on masonite 67.3 x 106.7 cm
Collection of Alcan Smelters and Chemicals Ltd.,
Montreal

DRESSER AND DARK WINDOW
1981 oil on masonite 92.7 x 106.7 cm
Collection of J. Ron Longstaffe

WHALING STATION
1983 oil on masonite 101.6 x 228.6 cm
Collection of the Vancouver Art Gallery. Gift of
Dr. and Mrs. N.B. Keevil

FLASHLIGHT
1983 oil on particle board 53.4 x 63.5cm
Collection of Joan Carlisle-Irving

GIRL IN SPARE ROOM
1984 oil on masonite 69.9 x 92.7 cm
Courtesy of Mira Godard Gallery, Toronto

LIGHT FROM ROOM UPSTAIRS
1984 oil on masonite 116.8 x 100.4 cm
Courtesy of Mira Godard Gallery, Toronto

PINK SINK
1984 oil on masonite 177.8 x 76.2 cm
Courtesy of Mira Godard Gallery, Toronto

WATERCOLOURS

SOUTH SIDE
1953 gouache on paper 21.6 x 15.3 cm
Collection of Christopher Pratt

BATTERY ROAD
1956 watercolour on paper 39.4 x 49.5 cm
Collection of Mr. Dalton Robertson

GROSVENOR CRESCENT
1957 watercolour on paper 47 x 72.7 cm
Collection of Mary Pratt

SHEDS ON ST. JOSEPH'S BEACH
1963 watercolour on paper 17.5 x 34 cm
Collection of Edythe Goodridge

OUTPORT BUSINESS
1964 watercolour on paper 32.7 x 66.7 cm
Collection of the Vancouver Art Gallery. Vancouver Art Gallery Alumnae of the Women's Auxiliary, Ella May Fell Bequest, The Canada Council

COAST WINTER
1965 watercolour on paper 34.3 x 74.9 cm
Collection of Wilfrid J. Ayre

DRAWINGS

BIRCH TREE
1963 graphite on paper 20.3 x 16.5 cm
Collection of Christopher Pratt

TREES BY THE RIVER
1963 graphite on paper 20.3 x 16.5 cm
Collection of Christopher Pratt

WINDOW BY THE SEA
1963 graphite on paper 30.5 x 19.1 cm
Collection of Memorial University Art Gallery, St. John's

THE EMPTY ROOM
1964 graphite on board 33 x 38.1 cm
Collection of Memorial University Art Gallery, St. John's

TRUCKS PASSING
1965 graphite on paper 22.9 x 36.9 cm
Collection of Anna Elton-Morris

AN EGG
1967 ink on gesso wash 11.4 x 8.9 cm
Collection of Mrs. Lieda Bell

NUDE LYING DOWN
1967 graphite on paper 23 x 56 cm
Collection of Philip Pratt

SELF PORTRAIT
1968 ink on gesso wash 20.3 x 10.2 cm
Collection of Mary Pratt

SHED DOOR
1968 graphite on paper 30.3 x 30.4 cm
Collection of Richard and Sandra Gwyn

ST. JOHN'S CENTRE
1969 ink and graphite on paper 38 x 28 cm
Private collection

STANDING NUDE
1970 graphite on paper 24.8 x 14.6 cm
Collection of Mr. and Mrs. Rawdon Jackson

WOMAN IN BLACK
1971 graphite on paper 36.5 cm diameter
Private collection

GIRL SITTING
1972 graphite on paper 38.1 x 25.4 cm
Collection of Christopher Pratt

LIGHTHOUSE DOOR
1972 graphite on paper 43.2 x 28 cm
Courtesy of Mira Godard Gallery, Toronto

GIRL WITH SMALL BREASTS
1974 graphite on paper 35.6 x 45.7 cm
Collection of Anna Elton-Morris

NUDE AND STUDIES
1974 graphite on paper 28 x 49 cm
Collection of Dr. H.H. Just

NUDE WITH RAISED ARMS
1975 graphite on paper 28 x 17.8 cm
Private collection

GIRL LYING DOWN
1980 graphite on paper 21.6 x 35.6 cm
Collection of Bill and Gerry Campbell

SHY GIRL
1980 graphite on paper 22.9 x 31.8 cm
Collection of The University of Lethbridge Art Collections

LIGHT IN THE MIDDLE OF NOWHERE
1980 ink, graphite and gouache on gesso-treated paper 38.3 cm diameter
Collection of Mr. and Mrs R. Pafford

GIRL SITTING ON A BOX
1981 graphite on paper 45.7 x 25.4 cm
Private collection

DONNA ASLEEP IN MY STUDIO
1981 graphite on paper 21.6 x 36.9 cm
Collection of J. Ron Longstaffe

GIRL WITH NOTHING ON
1981 graphite on paper 32.4 x 37.5 cm
Private collection

MADONNA
1981 graphite on paper 45.7 x 25.4 cm
Private collection

BRENDA WEARING BLACK
1982 graphite on paper 28 x 20.3 cm
Collection of Mr. and Mrs. John H. Moore

GIRL ON MY COUCH
1984 graphite on paper 28 x 50.8 cm
Private collection

DIANE STANDING
1984 graphite on paper 50 x 29 cm
Courtesy of Mira Godard Gallery, Toronto

DIANE TURNING
1984 graphite on paper 49 x 35 cm
Courtesy of Mira Godard Gallery, Toronto

PRINTS

HAYSTACKS IN DECEMBER
1960 silkscreen 2/6 29.2 x 71.2 cm
Collection of Christopher Pratt

BOAT IN SAND
1961 silkscreen 8/25 35.6 x 66 cm
Collection of Christopher Pratt

SHEDS IN WINTER
1964 silkscreen Artist's Proof 35.5 x 71 cm
Collection of Christopher Pratt

THE LYNX
1965 silkscreen 16/20 43.2 x 75 cm
Collection of Christopher Pratt

CLOTHESLINE
1965 silkscreen and mixed media 30.5 x 68 cm
Collection of David P. Silcox

TWO HOUSES IN THE SPRING
1968 silkscreen Artist's Proof 27.3 x 73.7 cm
Collection of Christopher Pratt

THE STAMP (FISH)
1968 silkscreen 49.5 x 66.7 cm
Collection of Philip Pratt

BLACK SEAL
1970 silkscreen Artist's Proof 40.6 x 52.5 cm
Collection of Christopher Pratt

SHEEP
1971 silkscreen 16/25 34.6 x 78.7 cm
Courtesy of Mira Godard Gallery, Toronto

ICE
1972 silkscreen 14/30 45.7 x 45.7 cm
Courtesy of Mira Godard Gallery, Toronto

STRAIT OF BELLE ISLE
1972 silkscreen 29/30 45.7 x 45.7 cm
Courtesy of Mira Godard Gallery, Toronto

LABRADOR CURRENT
1973 silkscreen 16/25 45.7 x 45.7 cm
Collection of J. Ron Longstaffe

GOOD FRIDAY
1973 silkscreen 13/25 50.8 x 58.2 cm
Courtesy of Mira Godard Gallery, Toronto

NEW BOAT
1975 silkscreen 44/55 36.9 x 76.2 cm
Courtesy of Mira Godard Gallery, Toronto

OCEAN RACER
1975 silkscreen 38.1 x 61 cm
Collection of J. Ron Longstaffe

BREAKWATER
1976 silkscreen 11/55 50.8 x 71.2 cm
Courtesy of Mira Godard Gallery, Toronto

HOUSE AT PATH END
1977 silkscreen 5/55 38.1 x 85.1 cm
Courtesy of Mira Godard Gallery, Toronto

MARCH CROSSING
1977 silkscreen 20/48 49.5 x 80 cm
Courtesy of Mira Godard Gallery, Toronto

FISHER'S MAID
1978 lithograph 41/50 30 x 37.8 cm
Collection of the Vancouver Art Gallery. Gift of J.
Ron Longstaffe

WESTERN SHORE
1979 silkscreen hors commerce 20.3 x 25.4 cm
Courtesy of Mira Godard Gallery, Toronto

LIGHT NORTHEAST
1979 silkscreen 8/45 38 x 43.5 cm
Collection of J. Ron Longstaffe

ABOVE MONTREAL
1979 silkscreen 6/40 50.8 x 58.4 cm
Collection of J. Ron Longstaffe

GASPÉ PASSAGE
1981 silkscreen 11/45 39.4 x 77.5 cm
Collection of J. Ron Longstaffe

MEMORIAL WINDOW
1982 silkscreen 7/55 44.5 x 50.8 cm
Collection of J. Ron Longstaffe

SACKVILLE ATTIC
1982 silkscreen 39/55 43.8 x 50.5 cm
Courtesy of Mira Godard Gallery, Toronto

NIGHT TRESTLE
1983 silkscreen 9/48 50.6 x 51 cm
Collection of J. Ron Longstaffe

YACHT WINTERING
1984 silkscreen 4/50 41.9 x 81 cm
Collection of J. Ron Longstaffe

STENCIL PROOFS

DECK LINES
1977 collage 51.2 x 80 cm
Private collection

BENCH AND DECK 2
1977 stencil proof 3/3 51.5 x 82 cm
Courtesy of Mira Godard Gallery, Toronto

BENCH AND RAIL 2
1977 stencil proof 2/4 51.5 x 82 cm
Courtesy of Mira Godard Gallery, Toronto

STUDIES

All studies are in the collection of Christopher Pratt
unless otherwise noted.

HAYSTACKS IN DECEMBER
Study no. 1 1959
ink on paper
11.1 x 24.5 cm

Study no. 2 1959
ink on paper
13.2 x 28 cm

Study no. 3 1959
ink on paper
14.4 x 32.6 cm

Study no. 4 1959
ink and graphite on paper
26.5 x 61.5 cm

DEMOLITIONS ON THE SOUTH SIDE
Study no. 1 1960
ink on paper
9.9 x 15.2 cm

Study no. 6 1960
ink on paper
15.5 x 25.8 cm

Study no. 7 1960
ink on paper
17.8 x 30 cm

Study no. 10 1960
ink and coloured pencil on paper
17 x 29.2 cm

Study no. 12 1960
graphite on paper
15 x 30 cm

Study no. 14 1960
graphite on tracing paper
15.2 x 30.7 cm

Study no. 15 1960
graphite on paper
21.2 x 43 cm

SHEDS IN WINTER
Study no. 1 1963
ink on paper
8 x 11 cm

Study no. 2 1963
ink and graphite on paper
7.5 x 13.3 cm

Study no. 3 1963
graphite on paper
11.5 x 18.5 cm

Study no. 4 1963
graphite on paper
13.5 x 17.8 cm

Study no. 5 1963
graphite on paper
12 x 21.5 cm

Pouch Cove Fishing Stages 1959
ink and graphite on paper
35.5 x 68.5 cm

WOMAN AT A DRESSER
Woman Sitting 1964
graphite on paper
38.1 x 25.4 cm
Collection of Mrs. Doreen Ayre